TangleEasy
Wildlife Designs

Design templates for Zentangle® coloring, and more

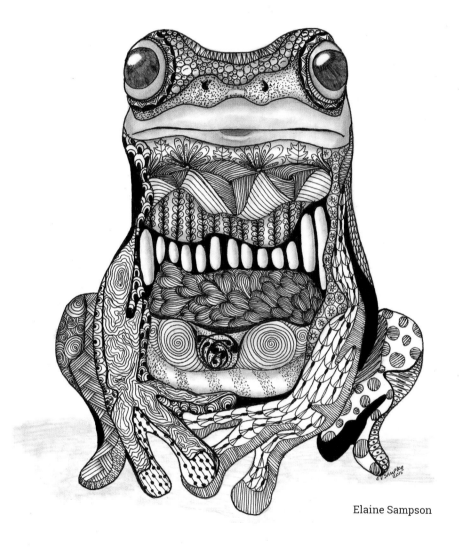

Elaine Sampson

BEN KWOK
creator of Ornation Creation

DESIGN ORIGINALS
an Imprint of Fox Chapel Publishing
www.d-originals.com

D1160180

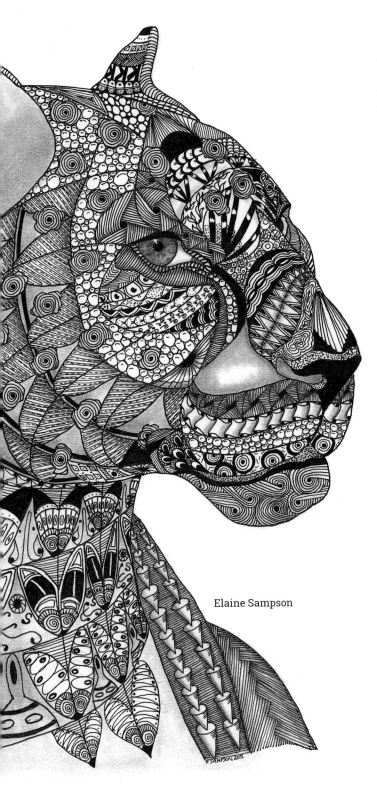

Elaine Sampson

About the Templates

Welcome to *TangleEasy Wildlife Designs*, a book filled with templates that you can use to create stunning colored and patterned art. My name is Ben Kwok, and I'm so excited to share these designs with you.

Art has always been a big part of my life. I've been drawing since I was four years old, keeping myself busy for endless hours when I was young by drawing on scrap pieces of paper. I am a very visual person, and while I was not good at some things, I always excelled at art. It seems to be an ingrained part of my personality. You could say I was born to be an artist, so art has always made sense to me, even at a young age.

I received a Bachelor of Fine Arts in Illustration from California State University, Long Beach and have worked as a graphic artist in the apparel industry for more than ten years. I've had the opportunity to work with several major brands, including Disney, Converse, and Lucky Brand. I find I most enjoy art that takes a very high skill level to accomplish. Some people like art to tell a story, but I personally like perfectly executed work. A good example is work by David A. Smith and Aaron Horkey. To me, these artists are the best in the world, and I am constantly inspired by them. I always strive for the same level of quality and perfection. I also like Art Nouveau, Biomechanics, Tattoo Flash, and Gig Posters.

In addition to my passion for art, I have a great love for animals and animal conservation. I regularly donate to the World Wildlife Fund and the Wildlife Conservation Network. Recently I've focused on the Save the Elephants project through WCN, an incredibly important effort in elephant conservation.

I started creating templates like the ones included in this book when I encountered Zentangle art. I noticed the Zentangle community was growing rapidly and producing lots of amazing work. While a lot of Zentangle art is abstract, there are also many who like to make Zentangle art in the shape of a particular object or animal. Many times these tanglers like to have an outline or other starting point to work from so they can focus on adding their intricate designs and not worry about having to sketch a realistic fish or other shape. I saw this missing piece in the puzzle, so I decided to start creating templates for Zentangle enthusiasts and doodlers alike to create intricately patterned artwork that had a distinct shape when they were finished. It seemed like a perfect fit.

When I started creating these templates, I had hopes of building a community centered on them, but the feedback and love I received was completely unexpected. I had no idea the templates would be so popular, or that they would have such a positive impact on the lives of others. I've

ISBN 978-1-4972-0027-2

© 2016 by Ben Kwok and New Design Originals Corporation, *www.d-originals.com*, an imprint of Fox Chapel Publishing, 800-457-9112, 1970 Broad Street, East Petersburg, PA 17520.

Cover art: Carole Giagnocavo (fox), Abbey Gray (kangaroo), Brooke Gustavel (wolf), Elaine Sampson (frog and giraffe).

Printed in the United States of America
First printing

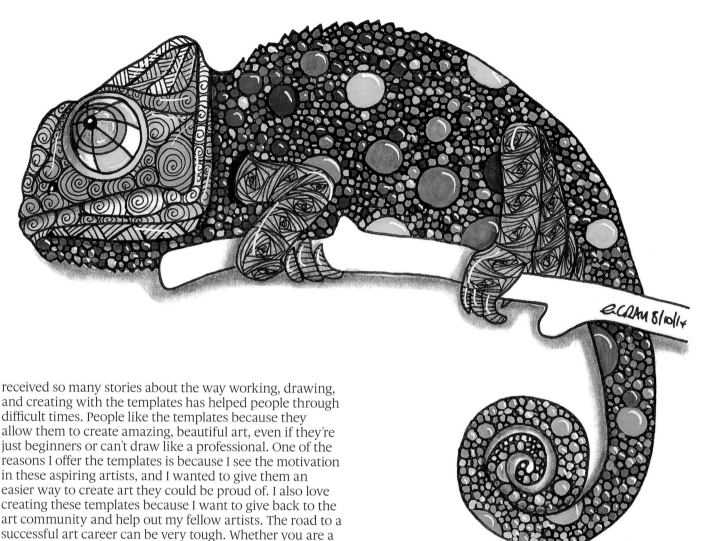

Abbey Gray

received so many stories about the way working, drawing, and creating with the templates has helped people through difficult times. People like the templates because they allow them to create amazing, beautiful art, even if they're just beginners or can't draw like a professional. One of the reasons I offer the templates is because I see the motivation in these aspiring artists, and I wanted to give them an easier way to create art they could be proud of. I also love creating these templates because I want to give back to the art community and help out my fellow artists. The road to a successful art career can be very tough. Whether you are a professional or an amateur doesn't matter to me. I feel like it's my duty to give back.

There are so many wonderful things that have come out of the creation of these templates, but my favorite by far is the feedback I receive from those who use them. To me, being appreciated for my efforts is priceless. I feel like I'm making a difference in people's lives, and that's a great feeling.

If you've picked up this book, you have the itch to create something amazing, and this is a great place to start. Some advice I always try to offer is to treat the template guidelines as just that: guides. Fight the temptation to follow the lines exactly. Although you can, you certainly don't have to. I think many people, especially if they are new to patterning, follow along the lines because they are afraid of what might happen if they deviate from the template. Don't be afraid to break away and explore what you can do beyond the lines. I think that's where the true magic and creativity happens. Use your imagination and see where you can go.

Through these templates, I want to continue nurturing the artist spirit that we all share. There are lots of hopes that I have for the future—in the spirit of continuing to give back, I'm considering ways to use the templates to support animal conservation. This seems like a fitting role for these designs. And of course, I'm very excited about what you'll do with the templates in this book.

Please visit *www.TangleEasy.com*, where you can see my latest work, access free template downloads, and explore a gallery of finished art created using my designs. For a glimpse at my own work as an artist, visit *www.BioWorkZ.com*.

Go create!
—Ben

Adding Color

There are so many ways you can color the templates in this book. Use your favorite medium—colored pencils, markers, pens, gel pens, watercolors—or combine different mediums to create unique effects. Remember, there is no right or wrong way to add color. If you're feeling a little unsure, take a look at the color wheel. Some very light research into color theory can give you loads of ideas for creating color palettes. Also, be sure to check out the color examples on the pages that follow for inspiration.

When purchasing coloring supplies, try to get the highest quality you can afford. You'll be much happier with the results. Test your purchases in a scrapbook to see how you like the color and quality. Make notes so you know what you liked and what you didn't for your next shopping trip. Have fun experimenting!

Markers. Markers are a great way to cover lots of ground and fill in large areas. Dual-tip markers come with a large brush end for big spaces, and a felt-tip end for small areas and details.

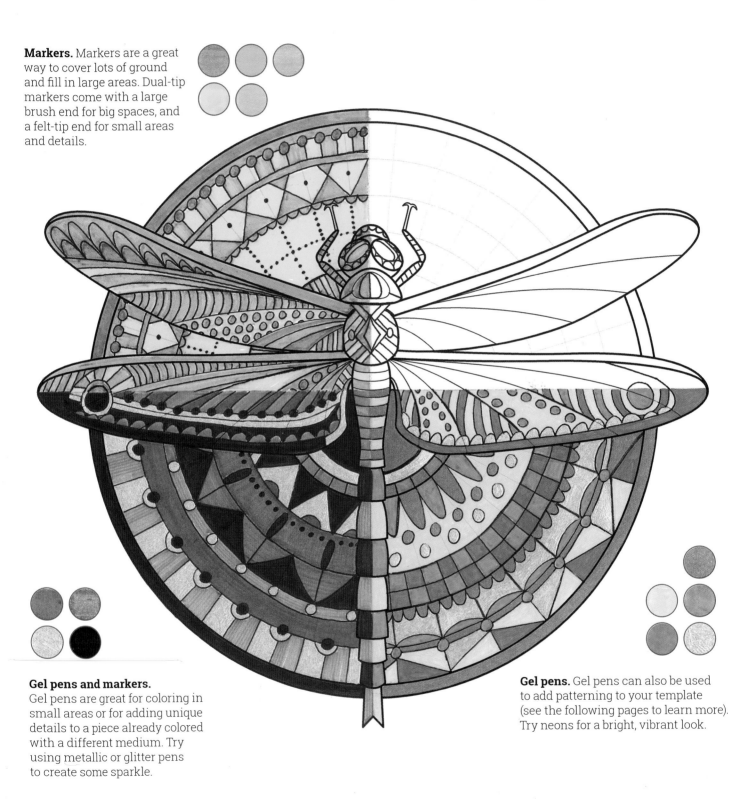

Gel pens and markers.
Gel pens are great for coloring in small areas or for adding unique details to a piece already colored with a different medium. Try using metallic or glitter pens to create some sparkle.

Gel pens. Gel pens can also be used to add patterning to your template (see the following pages to learn more). Try neons for a bright, vibrant look.

Markers. In addition to metallic gel pens, you can find metallic markers to add shine to large areas.

Colored pencils. Apply colored pencil using light pressure at first. Then go back and use more pressure in desired areas to create shading or more saturated colors.

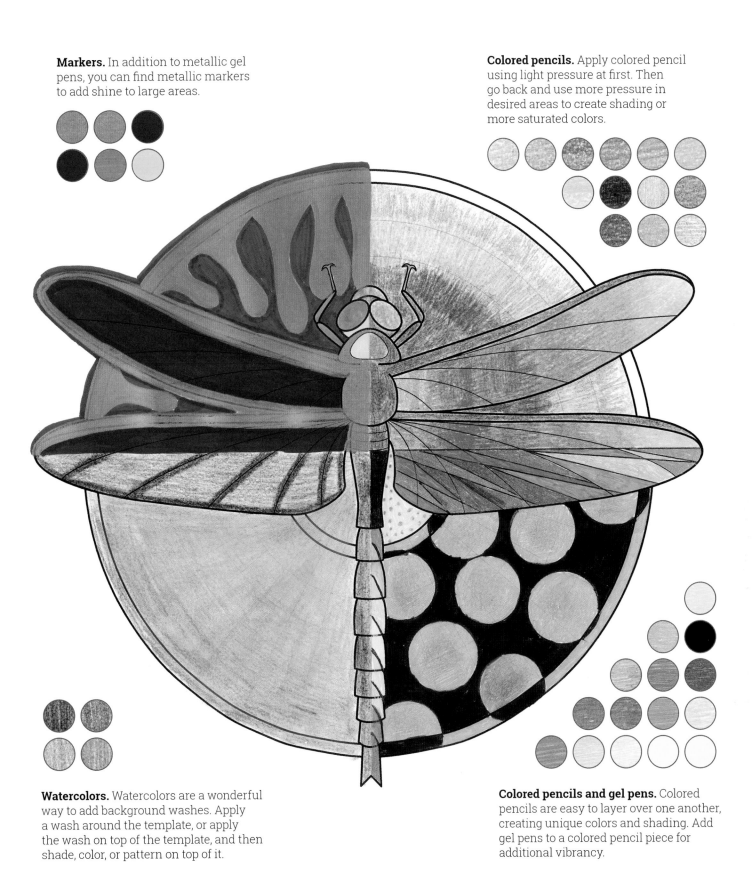

Watercolors. Watercolors are a wonderful way to add background washes. Apply a wash around the template, or apply the wash on top of the template, and then shade, color, or pattern on top of it.

Colored pencils and gel pens. Colored pencils are easy to layer over one another, creating unique colors and shading. Add gel pens to a colored pencil piece for additional vibrancy.

Adding Patterns

These templates were made to be embellished with patterning, and there are so many different ways to do it. The Zentangle method offers wonderful step-by-step designs, called tangles, to make patterning accessible for anyone. Try using some of the tangles on the following pages to fill a template. If you'd like to learn more about the Zentangle method, check out *Zentangle Basics, Expanded Workbook Edition*, or *Joy of Zentangle* to get started.

Simple patterning. You don't have to add a different pattern to every section in a template to create a beautiful finished piece. All of the sections in this frog were filled with the same pattern (very similar to the tangle Jute). By drawing the pattern at different sizes throughout the template, the artist created shading. Areas where the pattern lines are drawn far apart appear lighter, like the rock on which the frog is sitting. Areas where the pattern lines are drawn close together look dark, like the areas around the frog's eyes. Try picking just one pattern that you like and add it to all of the sections of a template.

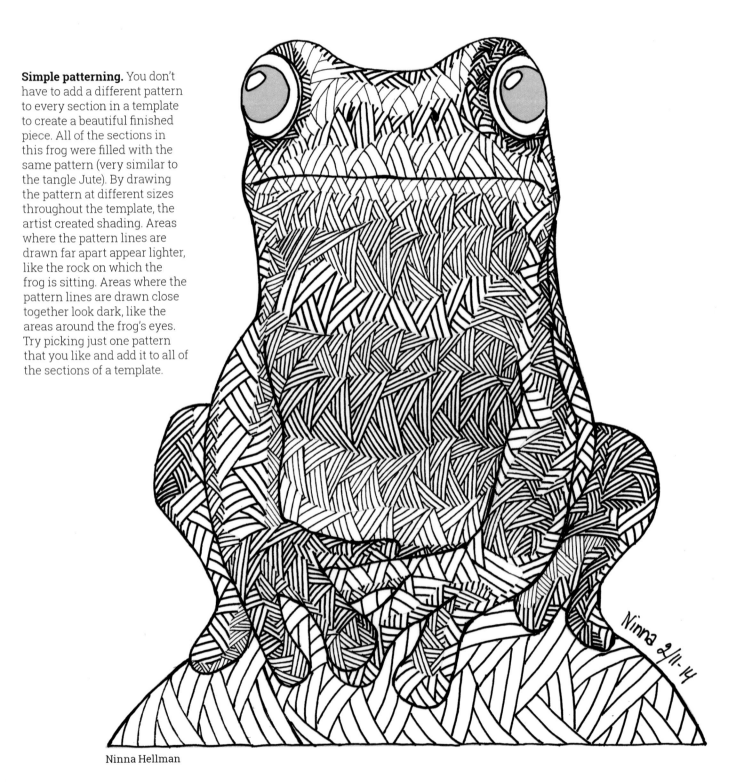

Ninna Hellman

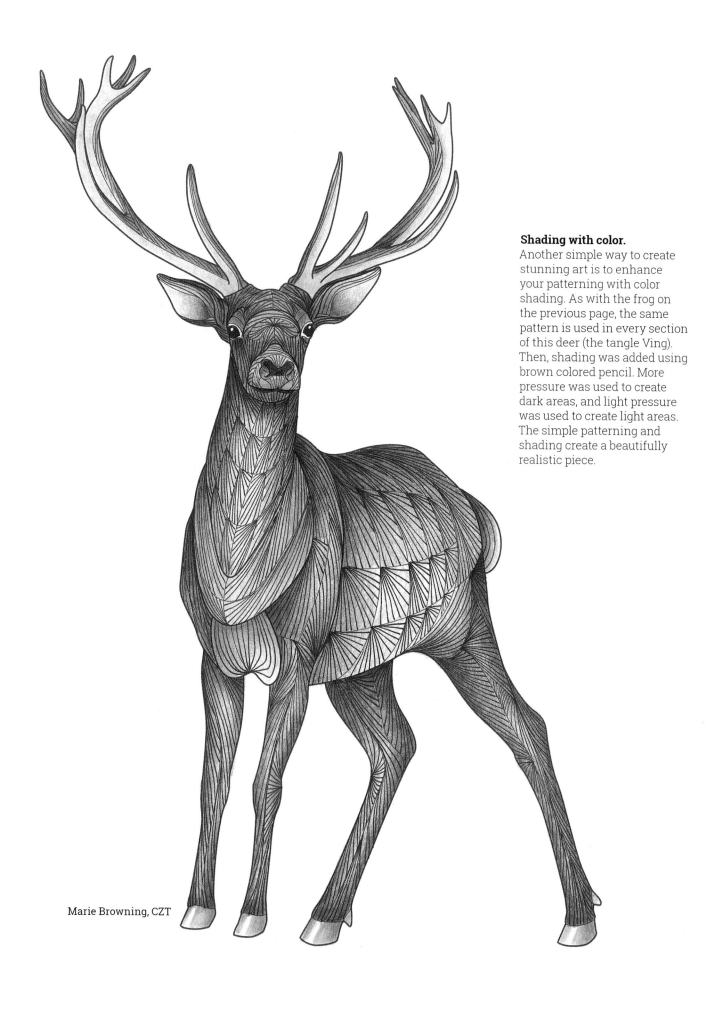

Shading with color.
Another simple way to create stunning art is to enhance your patterning with color shading. As with the frog on the previous page, the same pattern is used in every section of this deer (the tangle Ving). Then, shading was added using brown colored pencil. More pressure was used to create dark areas, and light pressure was used to create light areas. The simple patterning and shading create a beautifully realistic piece.

Marie Browning, CZT

Multiple patterns. As you become more comfortable with patterning, try adding a different pattern to each section of a template. This tortoise is filled with tangles.

Pigma Micron 01 black pens are the preferred drawing medium for tanglers. For any coloring or patterning, purchase the highest-quality supplies you can. You'll be much happier with the results.

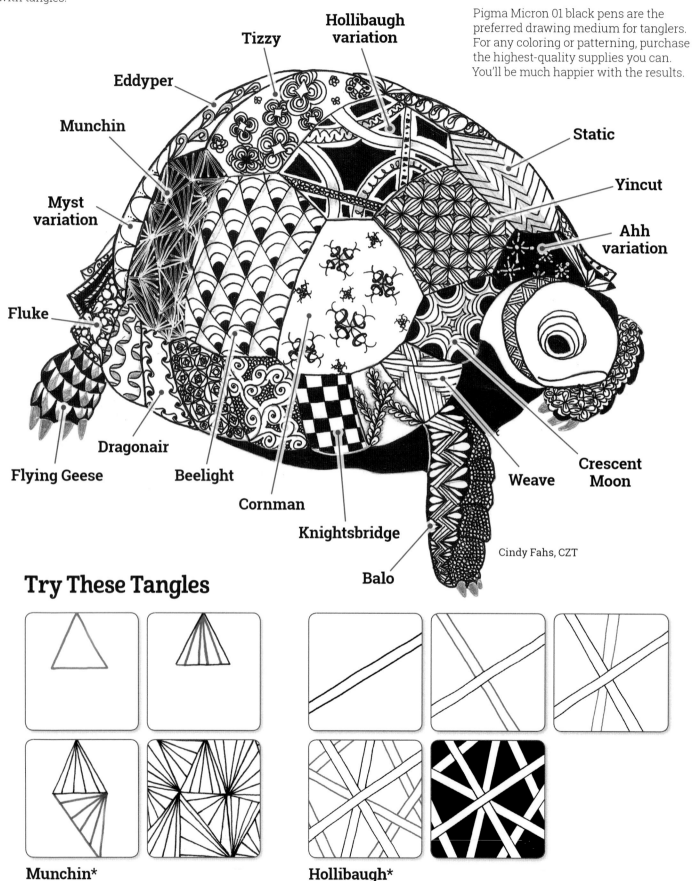

Tizzy

Hollibaugh variation

Eddyper

Munchin

Myst variation

Static

Yincut

Ahh variation

Fluke

Flying Geese

Dragonair

Beelight

Cornman

Knightsbridge

Balo

Weave

Crescent Moon

Cindy Fahs, CZT

Try These Tangles

Munchin*
*An original Zentangle design

Hollibaugh*
*An original Zentangle design

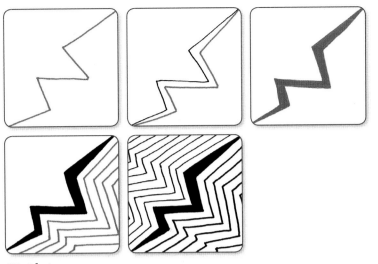

Static*
*An original Zentangle design

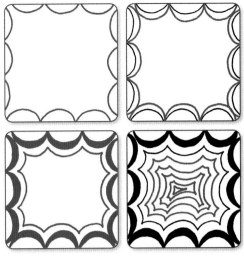

Crescent Moon*
*An original Zentangle design

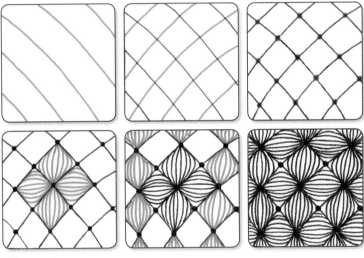

Yincut*
*An original Zentangle design

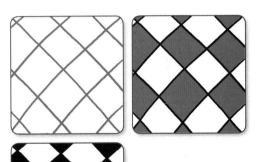

Knightsbridge*
*An original Zentangle design

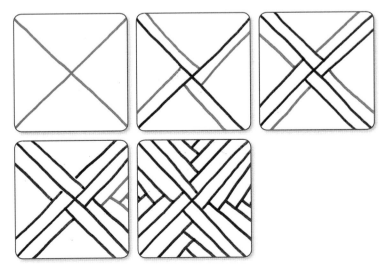

Weave

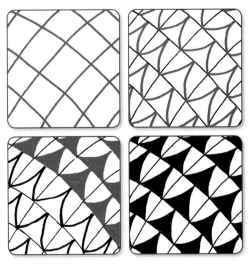

Flying Geese

Design Your Own Patterns

You can also add patterning by creating your own designs using simple shapes and lines. Checkerboards, polka dots, and stripes are all patterns that anyone can draw. Check out some of the freehand patterns below to get some ideas.

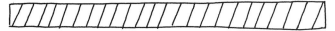

Stripes. Draw parallel lines to create stripes. You can use even spacing between the lines, or vary the spacing. Lines drawn close together will create dark areas, while lines drawn further apart will create light areas.

Varied stripes. You can make stripes curved or wavy for added interest. Add extra dots or lines for complexity.

Circles. Fill a template section with circles. You can draw them in orderly rows as shown, or add them in a completely random pattern. Vary the size of the circles or keep them uniform; fill them in or leave them open; allow them to overlap or keep them separated.

Checkerboard. Draw a grid and fill in alternating boxes for a checkerboard pattern. Use square or rectangular boxes. Or, draw a grid with curved lines for added interest.

Crescents. Crescent shapes are easy to repeat along a line. Build on your design by adding more rows of crescents, or draw dots or lines between each crescent as shown.

Extended crescents. These tall crescents make a great border around the edges of a section in a template.

Triangles. Draw a series of triangles next to each other. Divide the triangles in half as shown, or add more lines to divide the triangles into thirds or fourths. You can also add dots and circles.

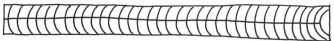

Overlapping triangles. Draw a series of triangles so that they overlap. Add extra lines and dots for complexity.

Circles and lines. Draw a series of circles. Then connect each one with a line. You can add more lines coming out from the circles. The lines can be straight and parallel, or go in any direction and crisscross.

Varied circles and lines. Add more complexity to the circles and lines design by filling in the circles and adding semi-circle outlines.

Inspirational Gallery

We asked people to share the amazing art they've been creating using the templates found in this book. We've featured their beautiful work here to spark your creativity and get ready to create some art of your own. Notice how the same template can look completely different depending on the way each artist used the guidelines and the patterns or colors added. Remember to put your individual touch and style on every piece you create. Have fun!

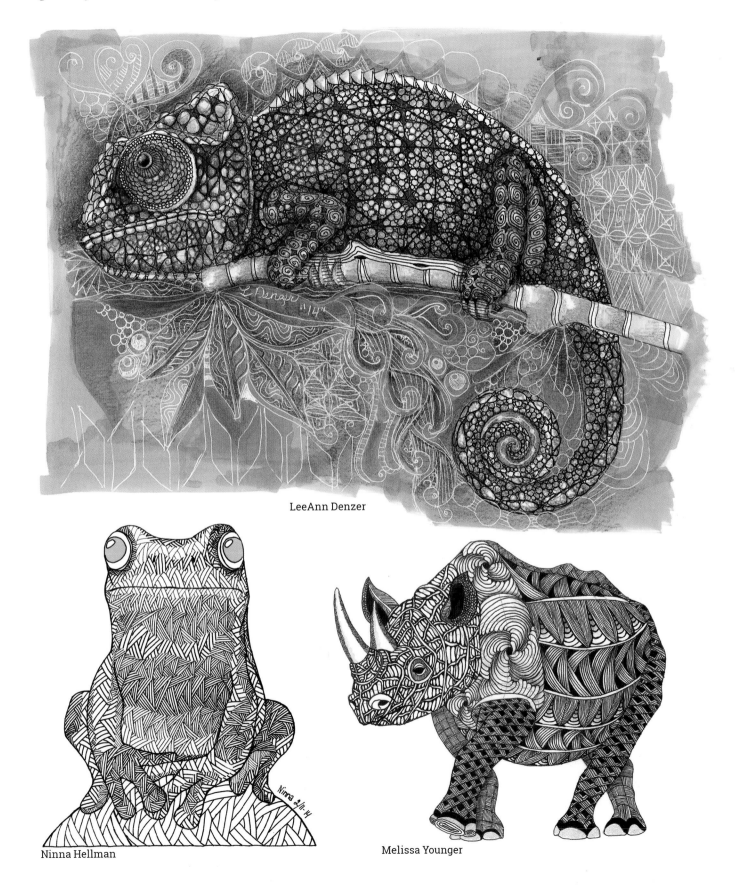

LeeAnn Denzer

Ninna Hellman

Melissa Younger

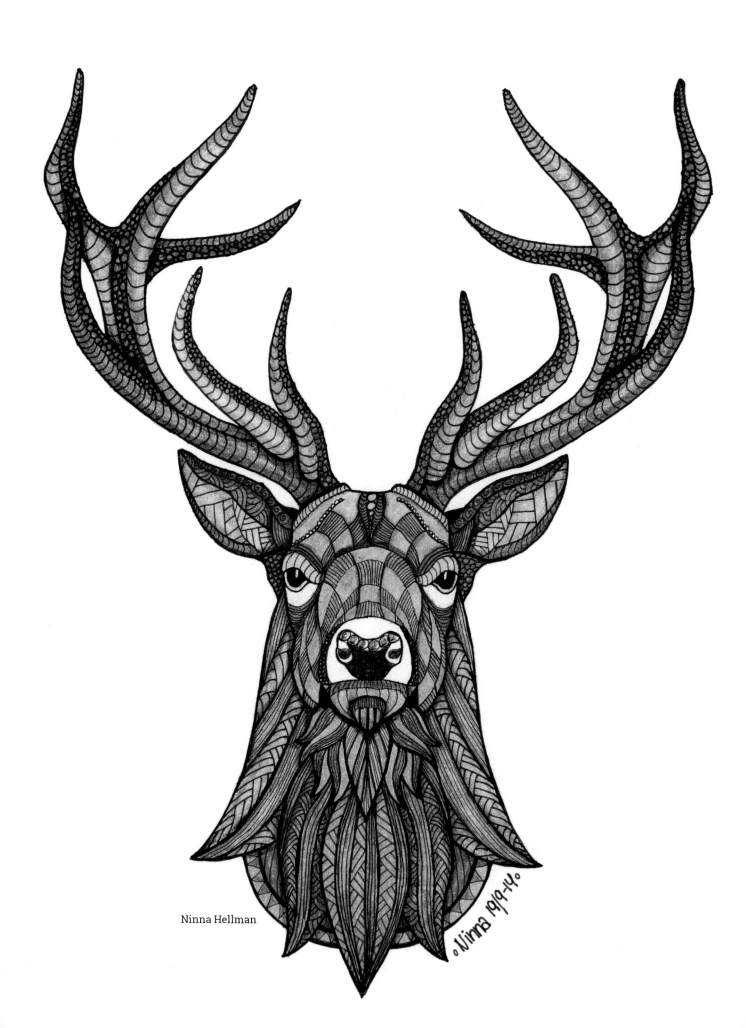

Ninna Hellman

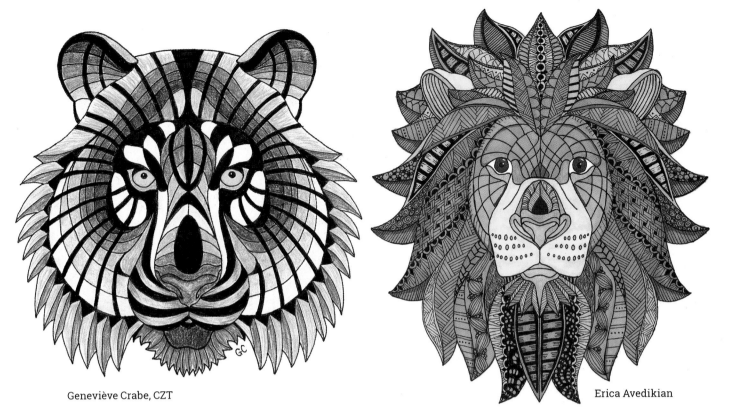

Geneviève Crabe, CZT

Erica Avedikian

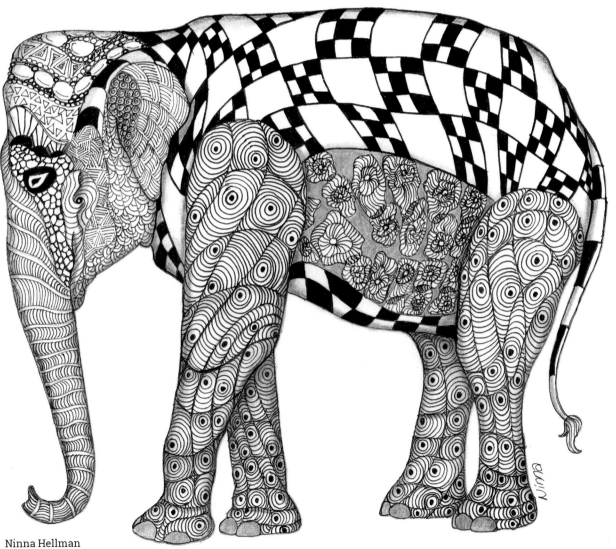

Ninna Hellman

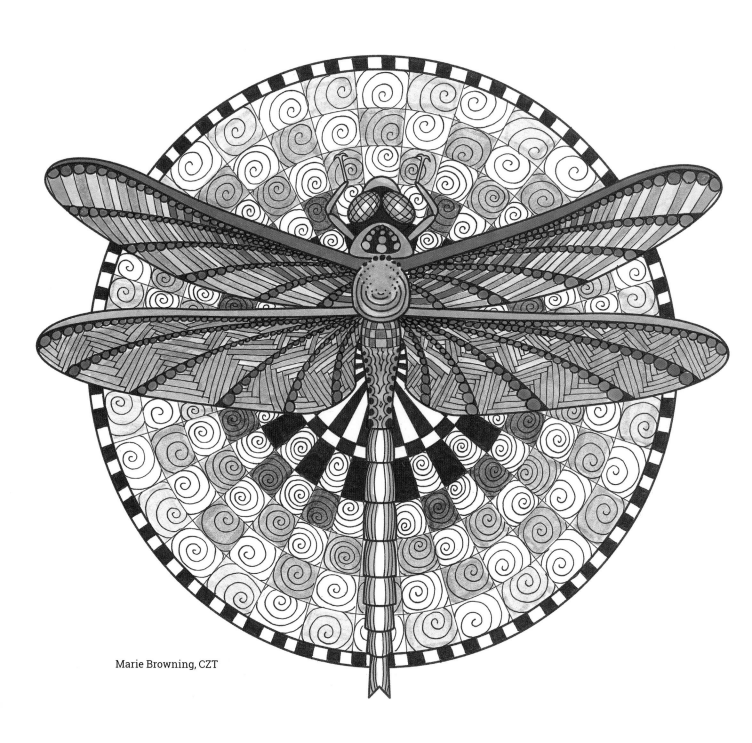

Marie Browning, CZT

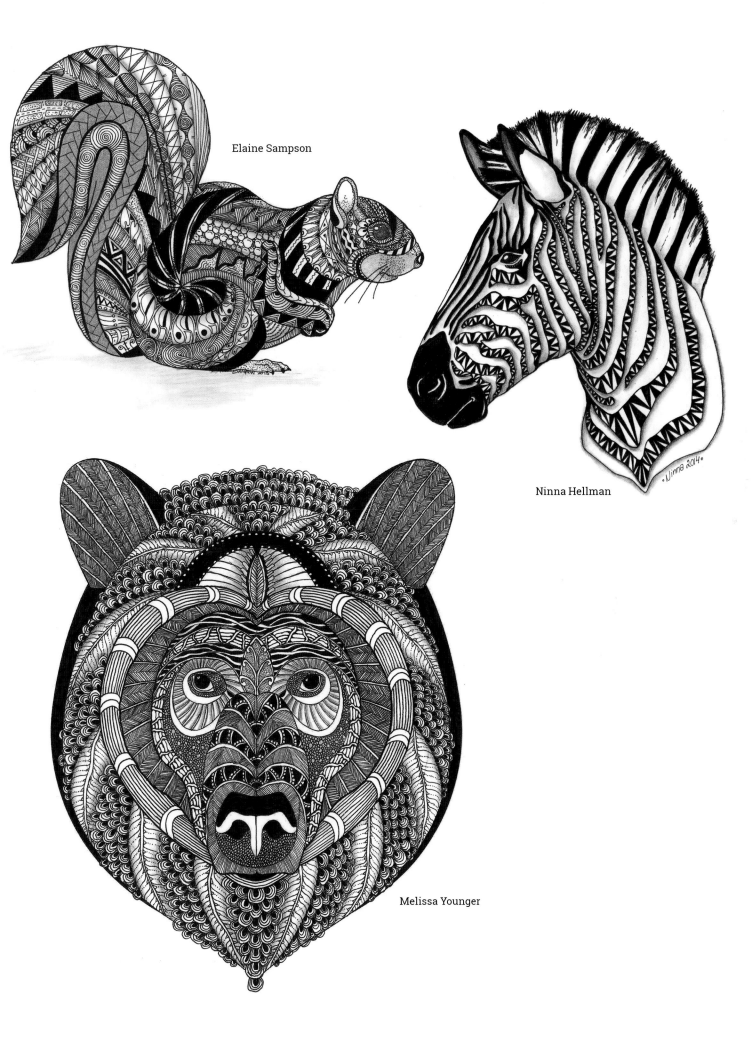

Elaine Sampson

Ninna Hellman

Melissa Younger

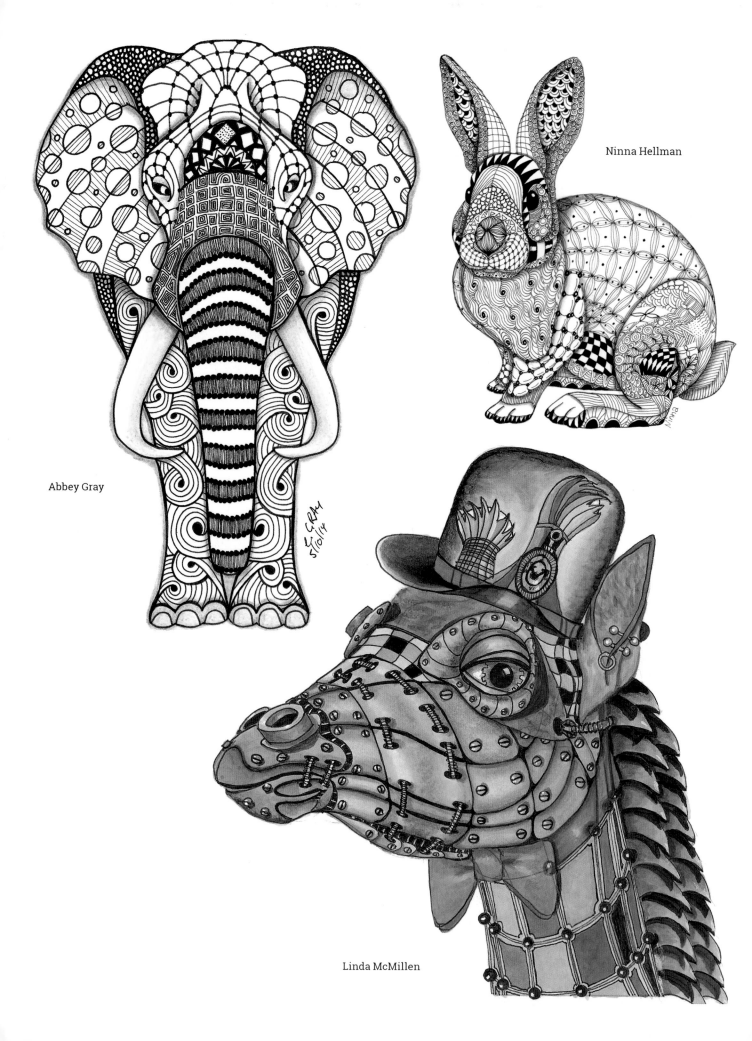

Ninna Hellman

Abbey Gray

Linda McMillen

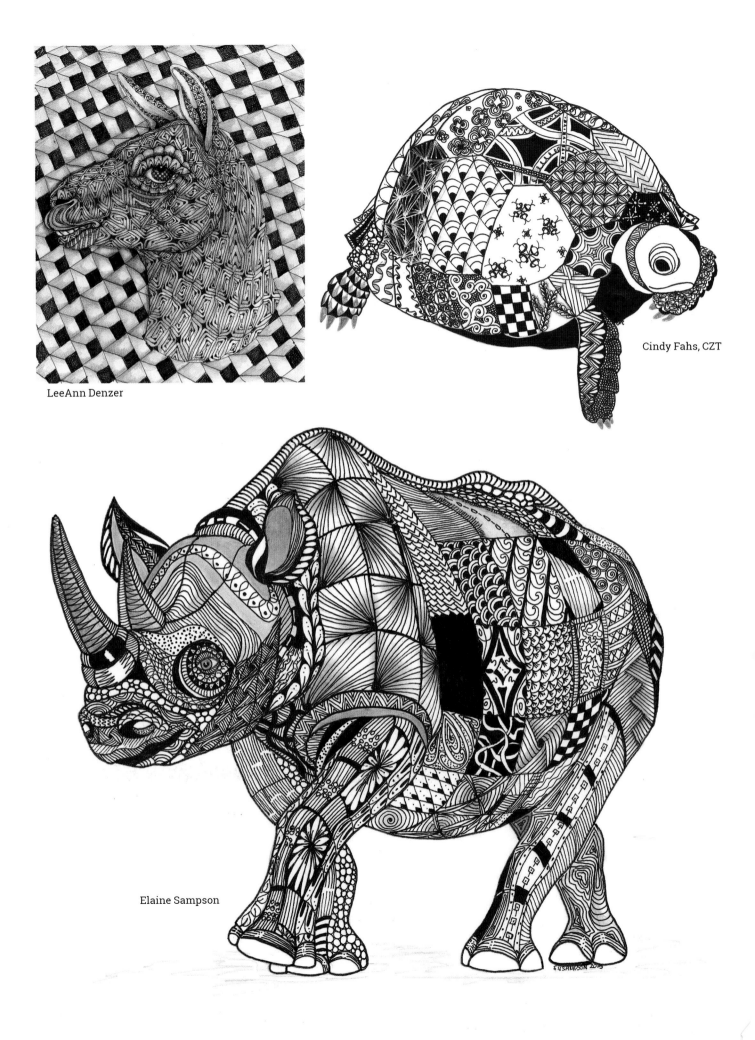

LeeAnn Denzer

Cindy Fahs, CZT

Elaine Sampson

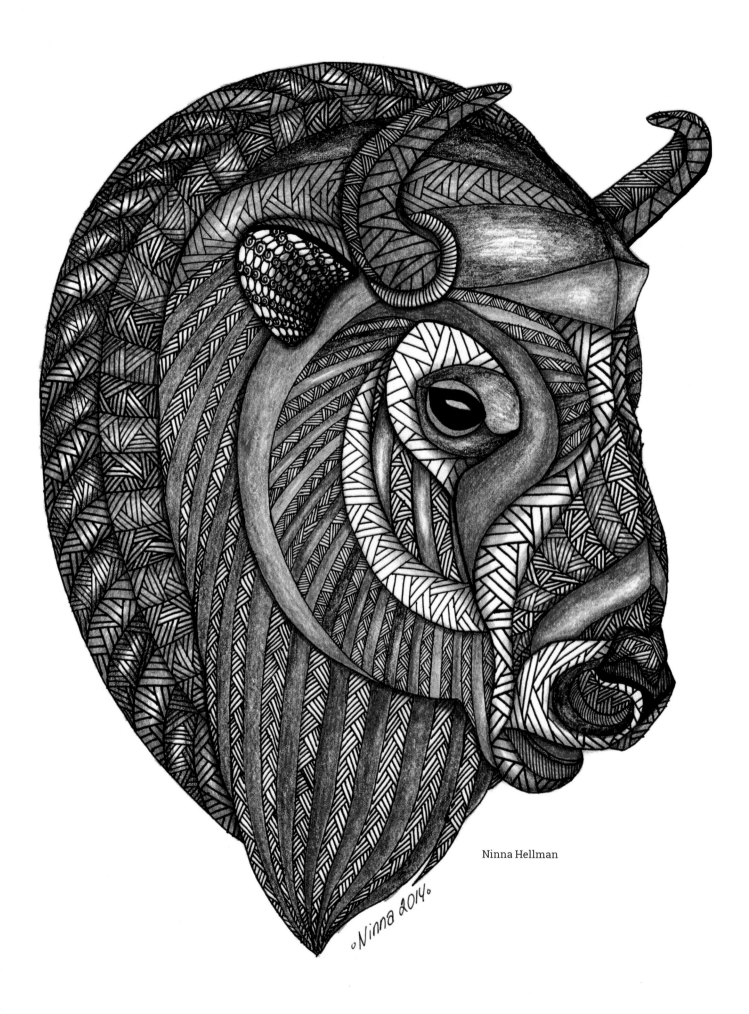

Ninna Hellman

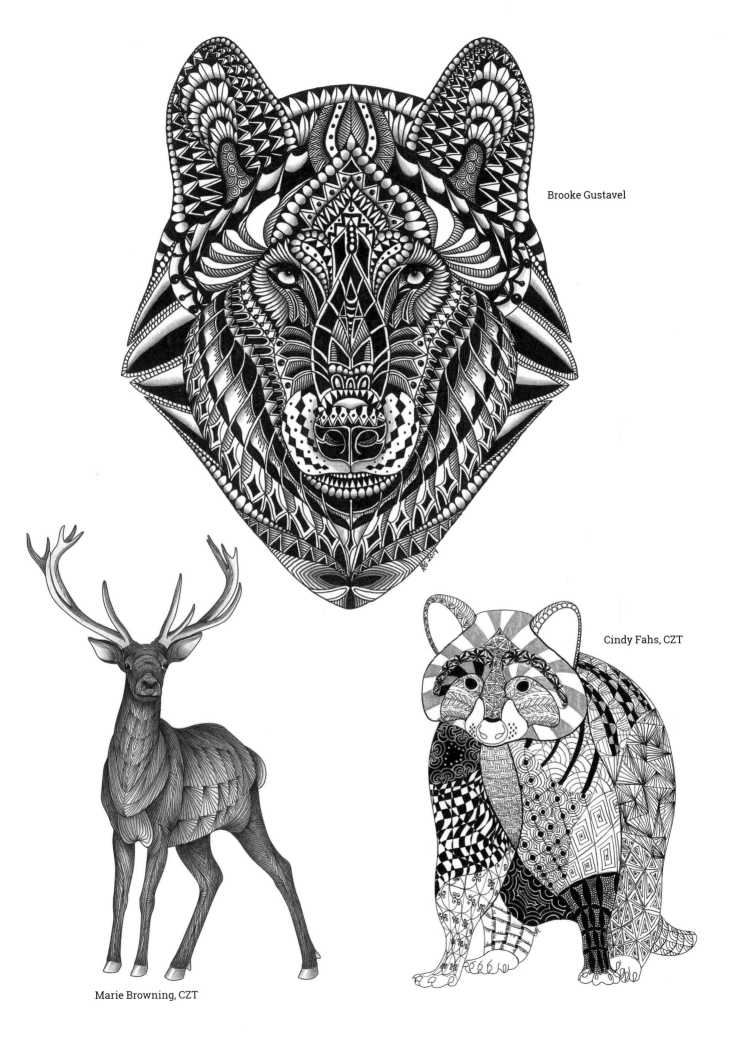

Brooke Gustavel

Cindy Fahs, CZT

Marie Browning, CZT

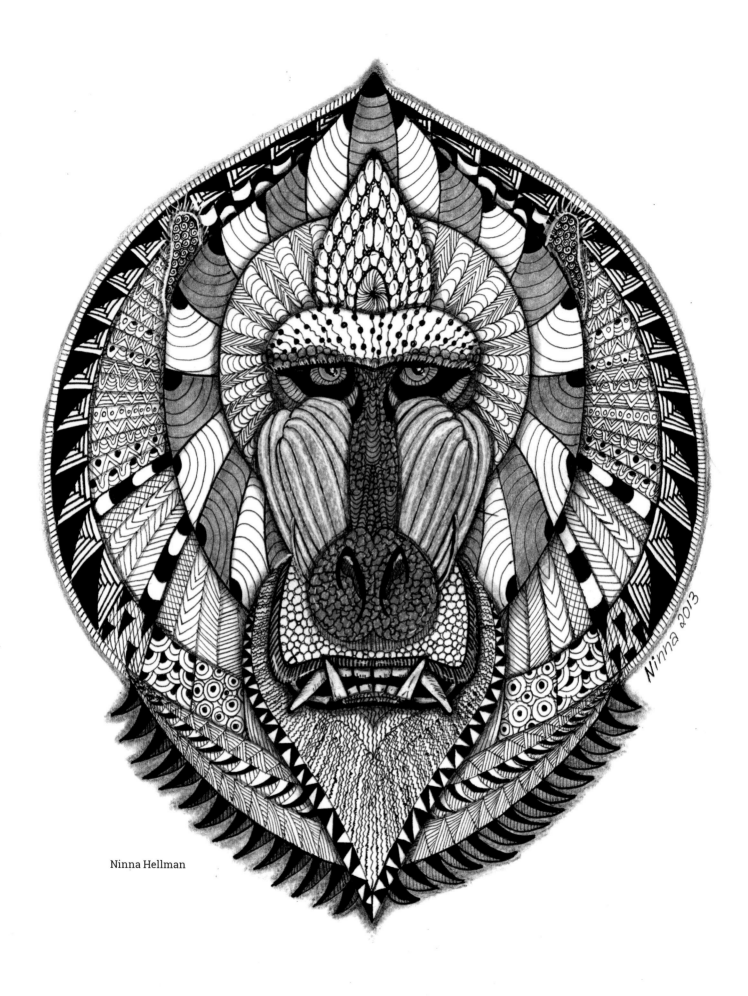

Ninna Hellman

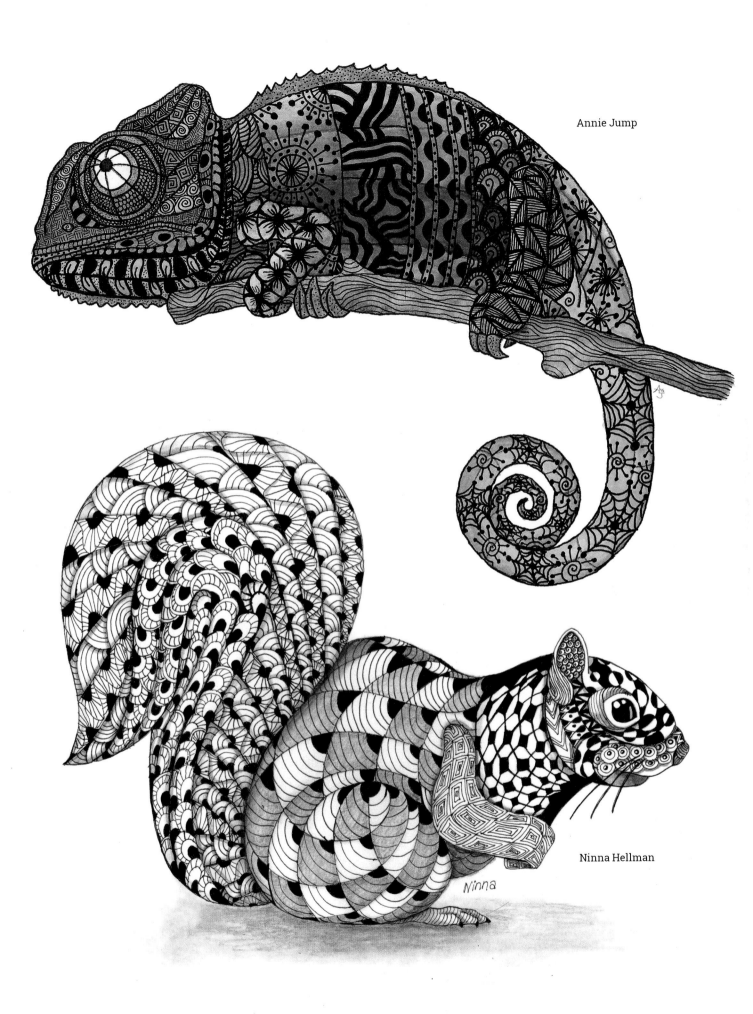

Annie Jump

Ninna Hellman

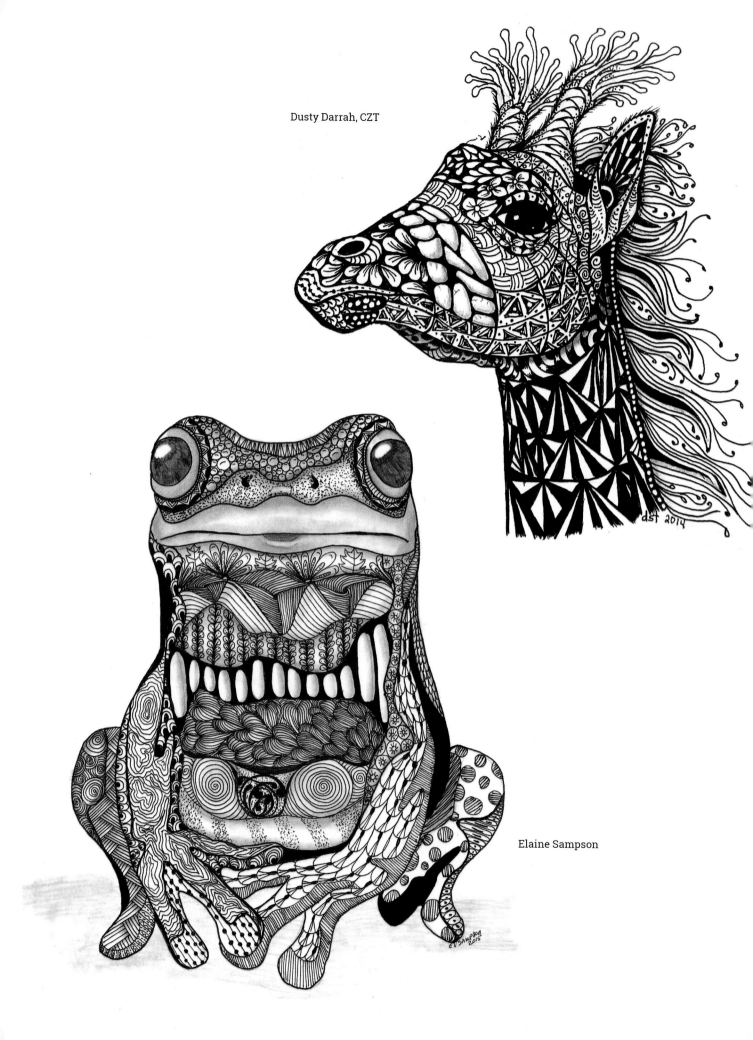

Dusty Darrah, CZT

Elaine Sampson

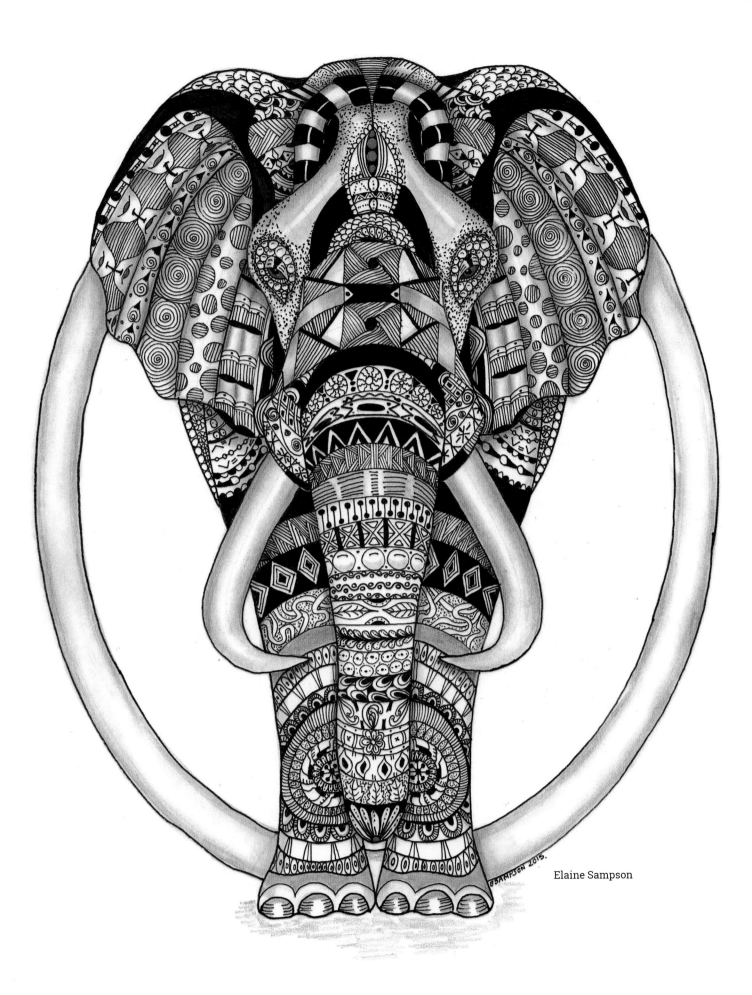

Elaine Sampson

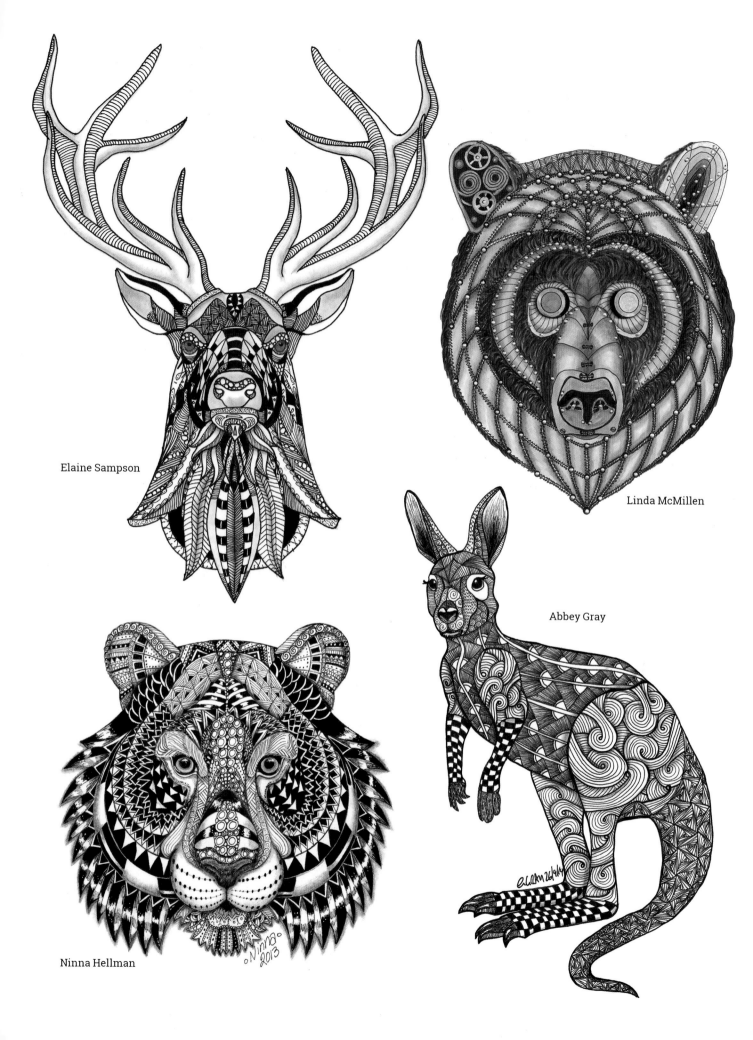

Elaine Sampson

Linda McMillen

Abbey Gray

Ninna Hellman

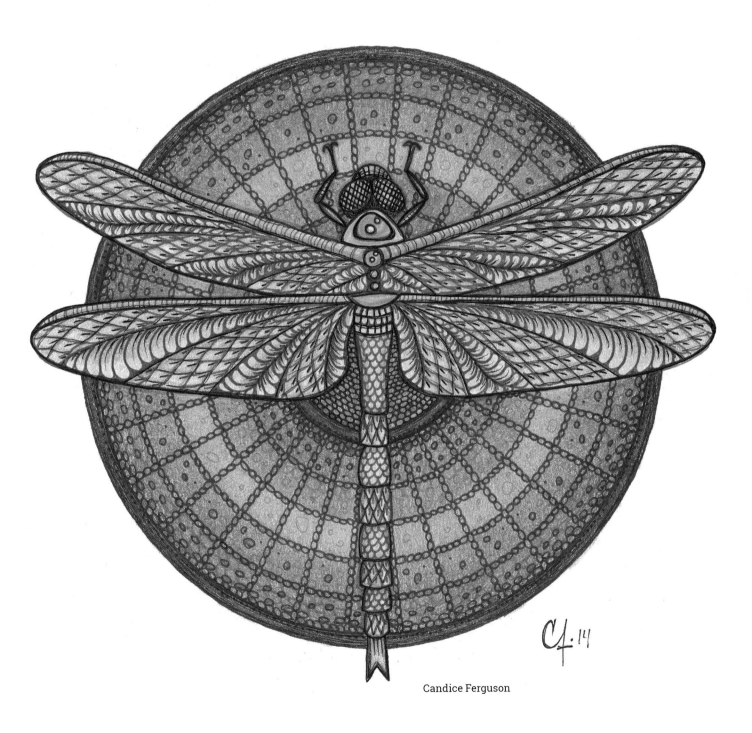

Candice Ferguson

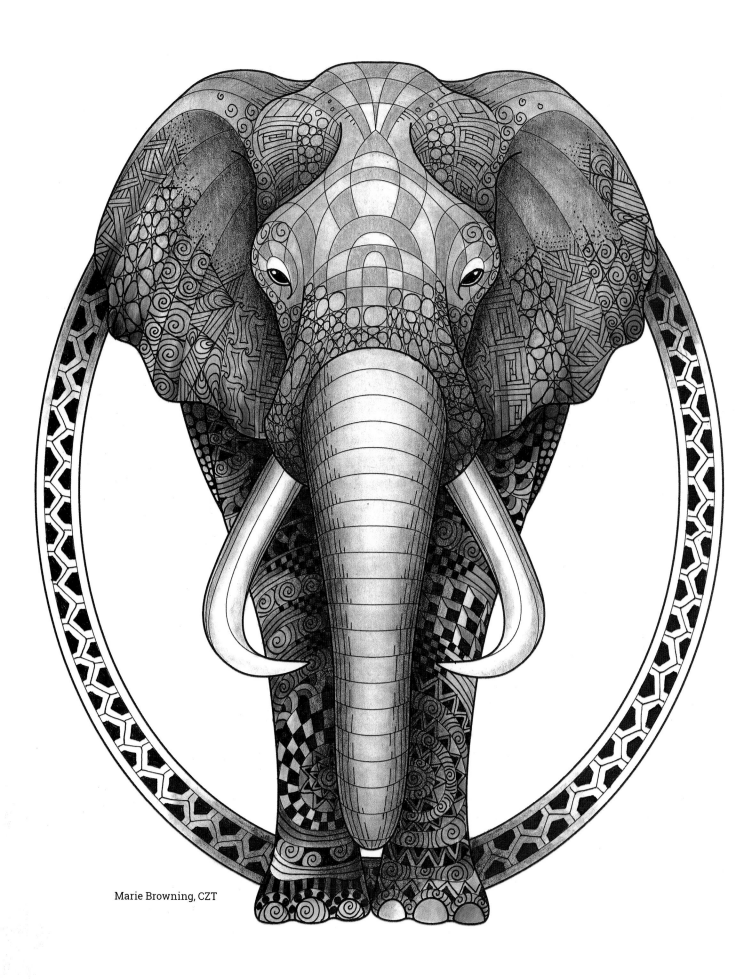

Marie Browning, CZT

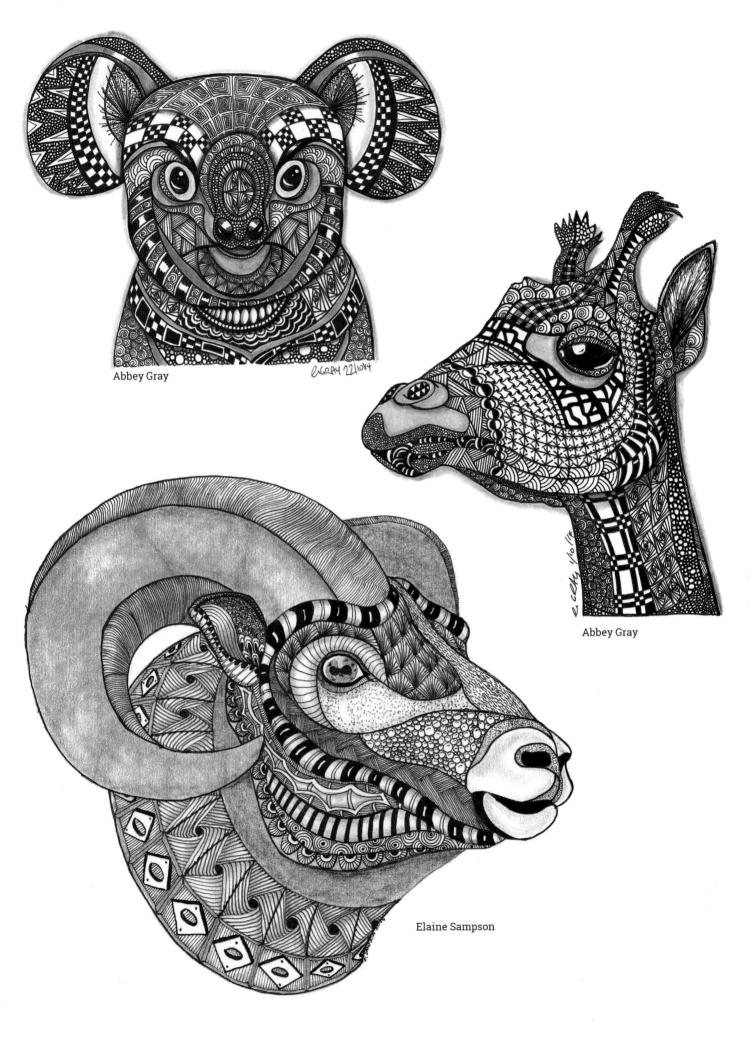

Abbey Gray

Abbey Gray

Elaine Sampson

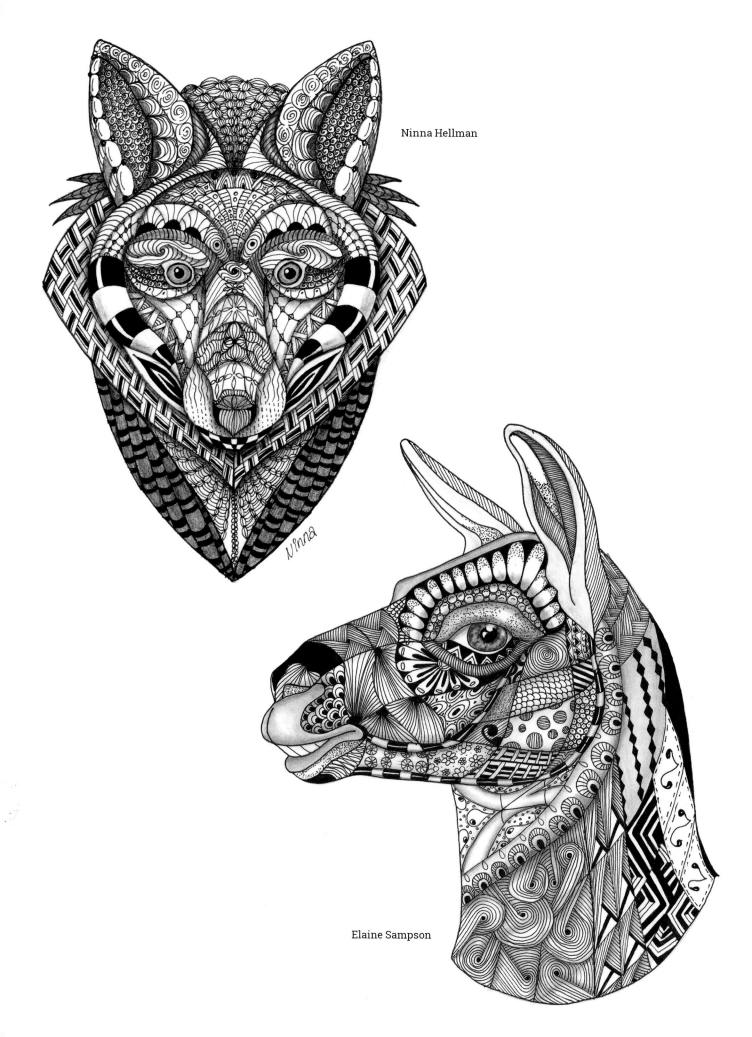

Ninna Hellman

Ninna

Elaine Sampson

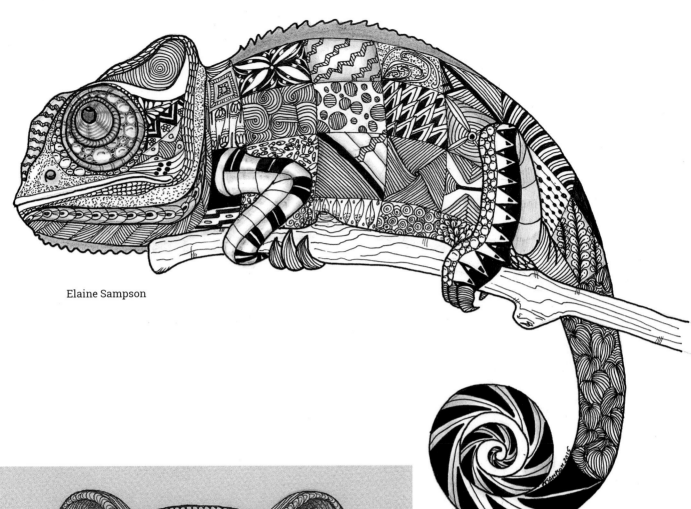

Elaine Sampson

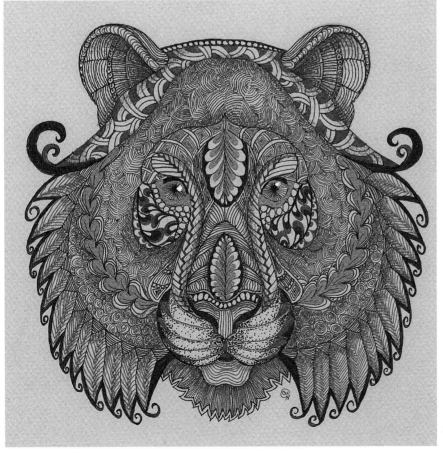

Cathy Wilson

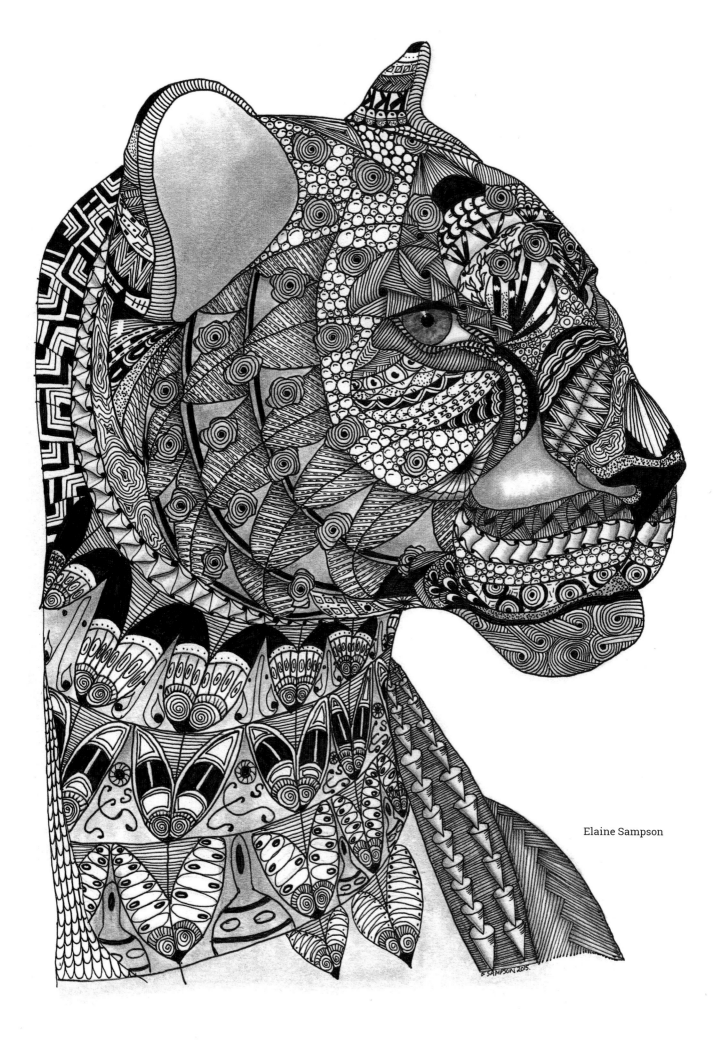

Elaine Sampson

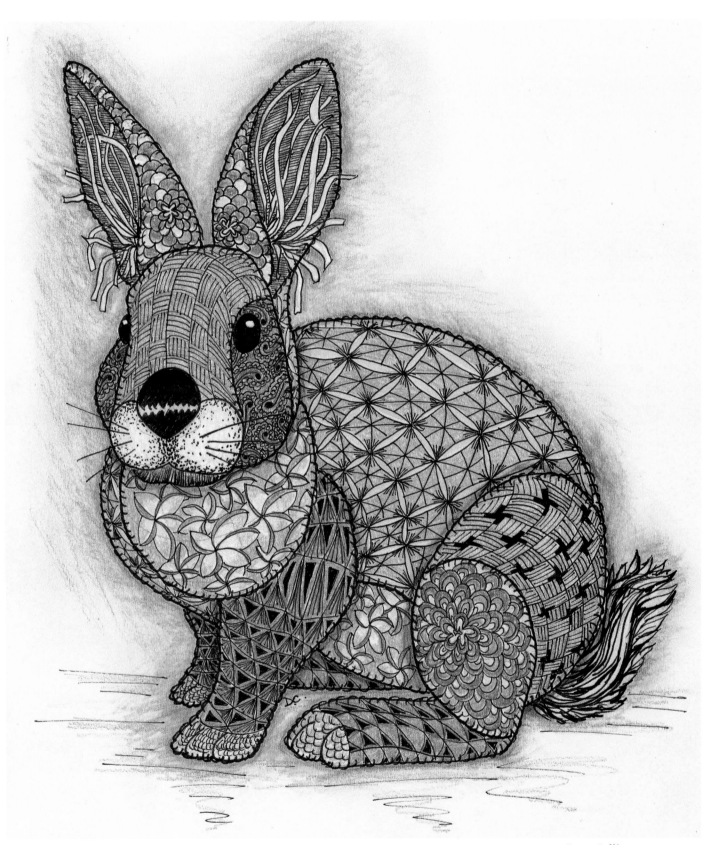

Dawn Collins

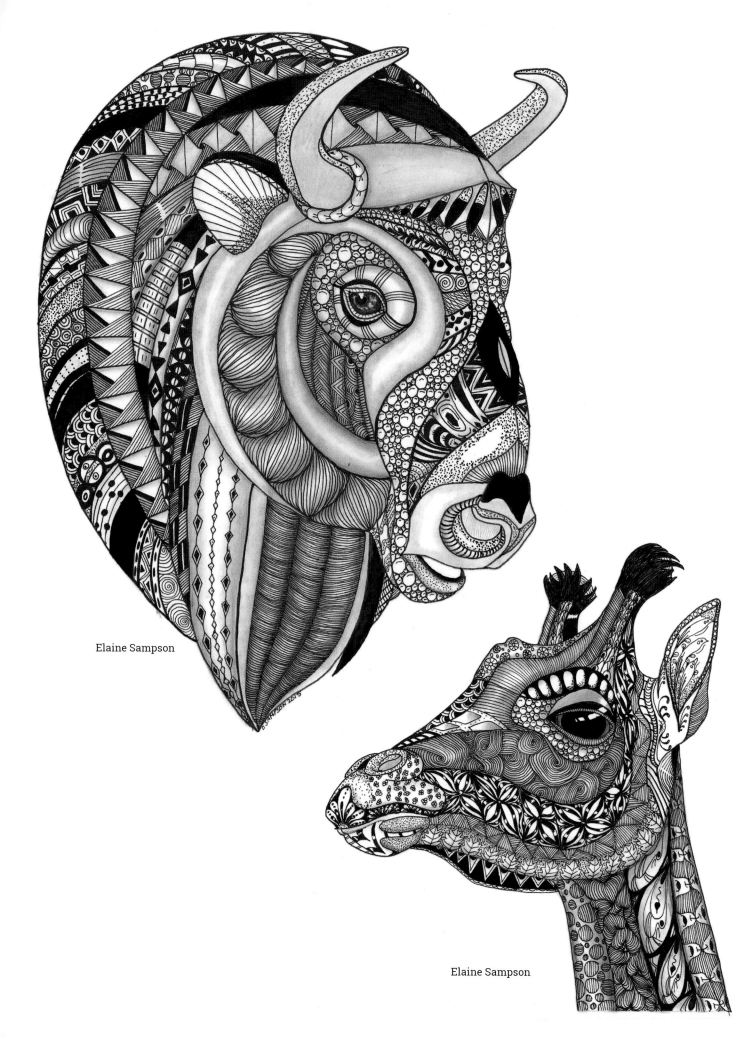

Elaine Sampson

Elaine Sampson

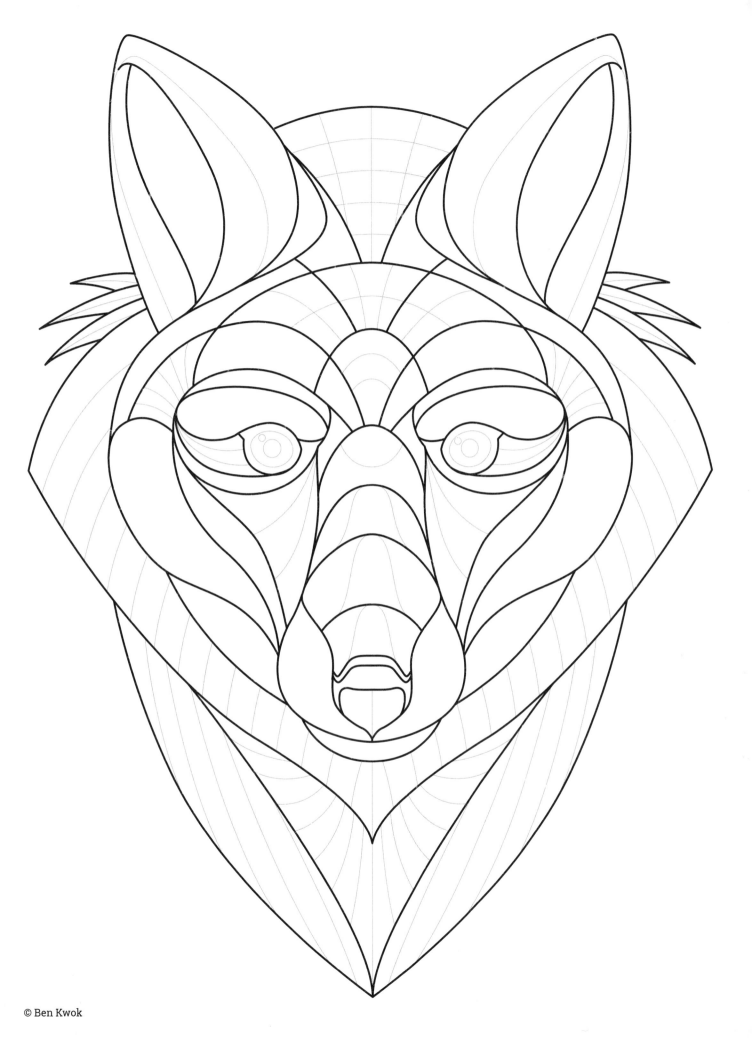

© Ben Kwok

All good things are wild and free.

—Henry David Thoreau

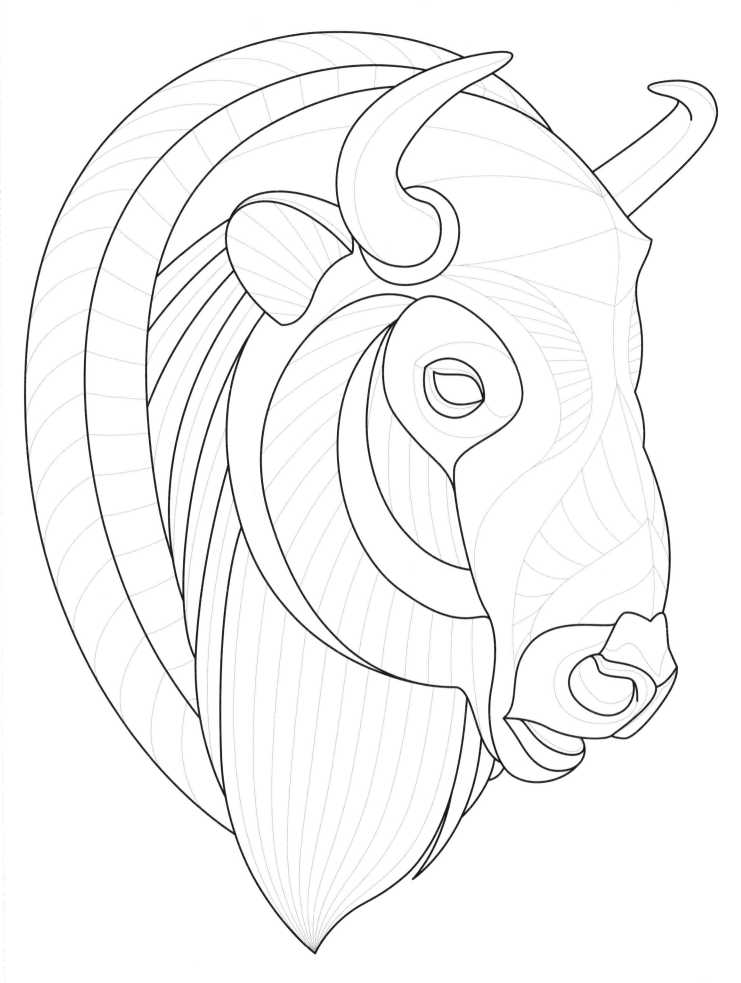

Those who contemplate the beauty of the Earth
find reserves of strength that will endure as
long as life lasts.

—Rachel Carson

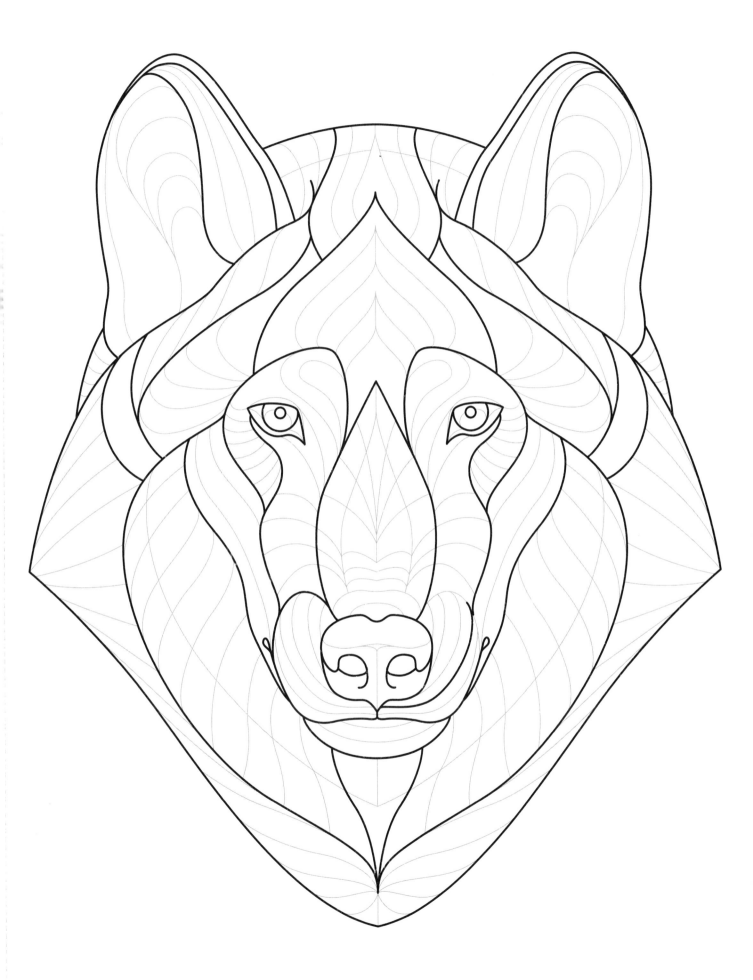

© Ben Kwok

Throw me to the wolves,
and I shall return, leading the pack.

—Unknown

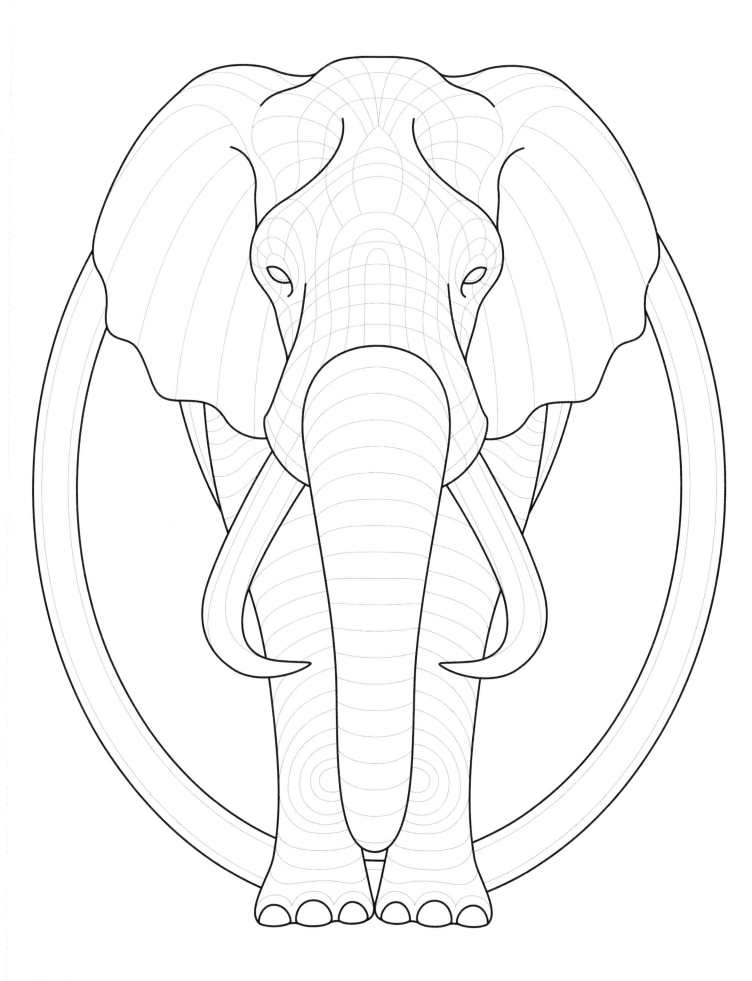

© Ben Kwok

Any glimpse into the life of an animal quickens
our own and makes it so much the larger and
better in every way.

—John Muir

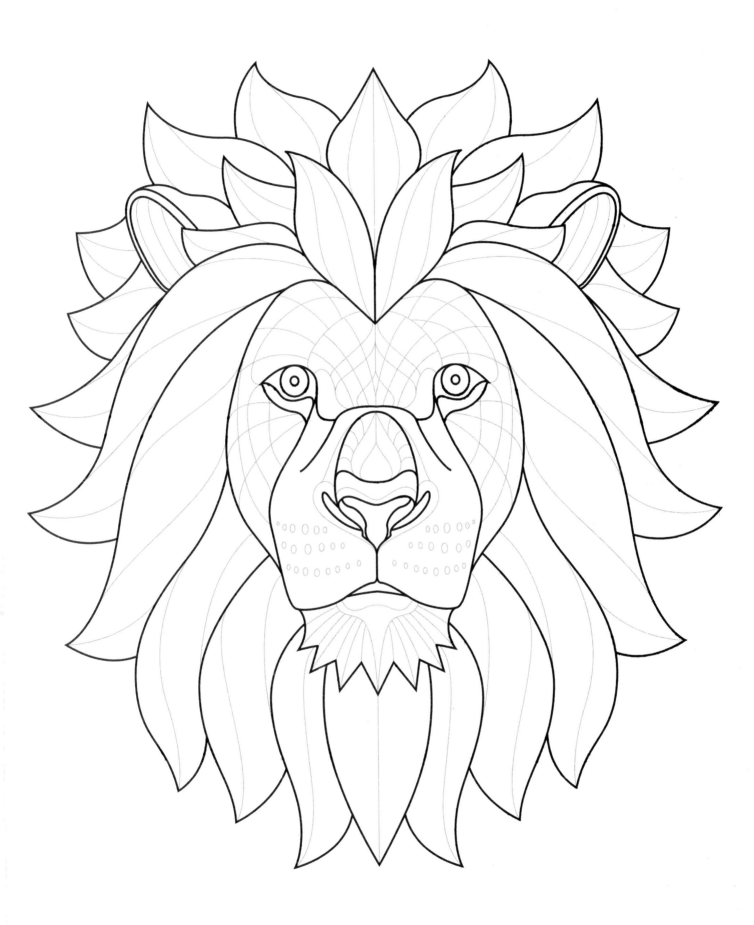

© Ben Kwok

A truly strong person does not need
the approval of others any more than
a lion needs the approval of sheep.

—Vernon Howard

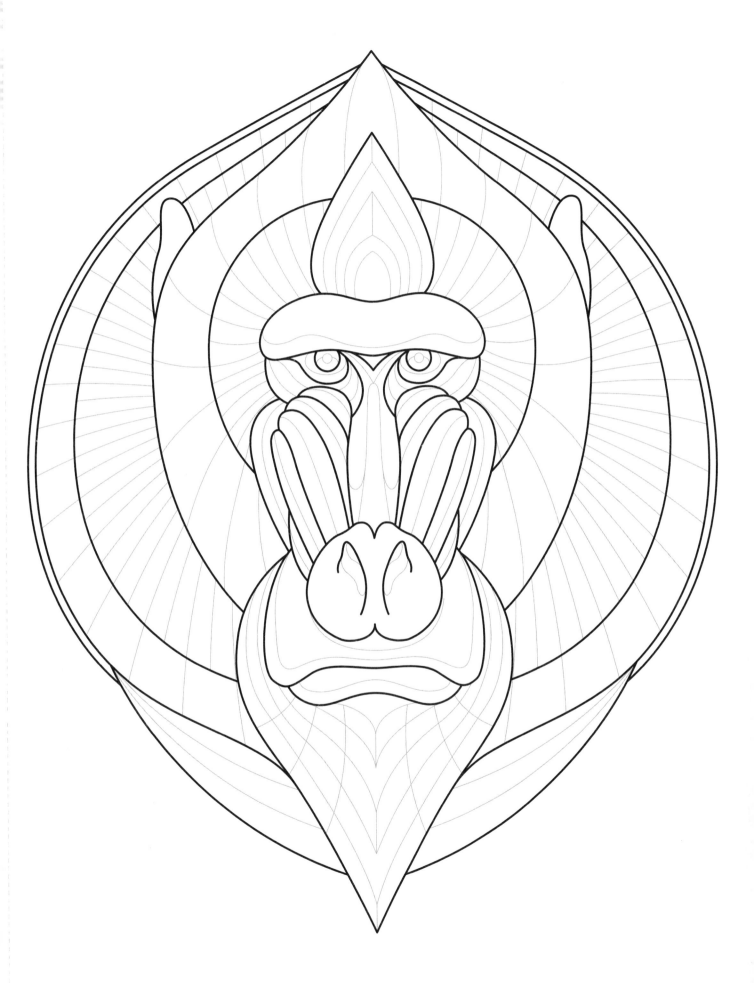

© Ben Kwok

Look deep into nature, and then you
will understand everything better.

—Albert Einstein

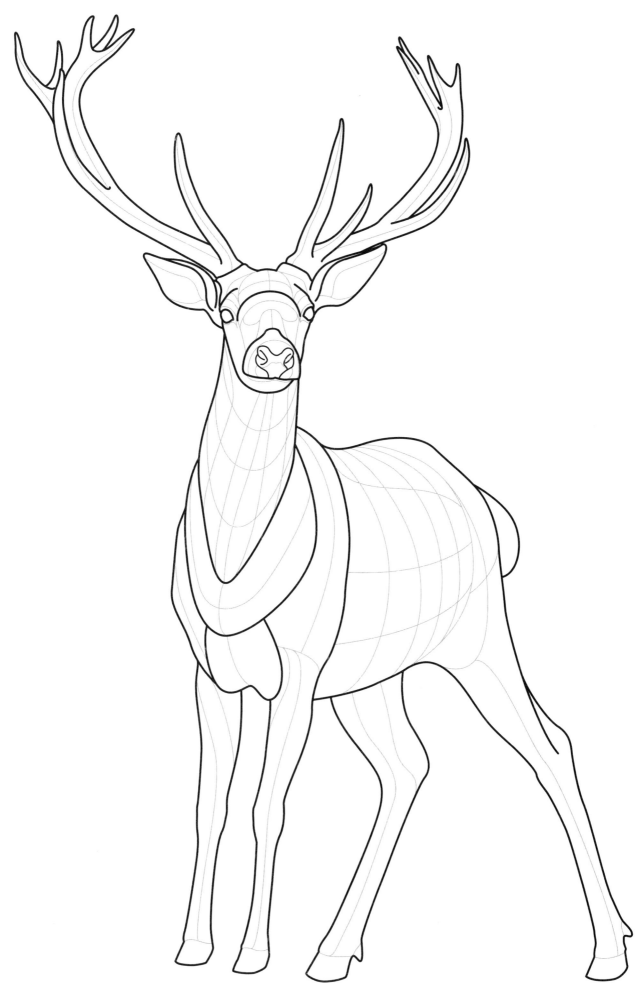

The clearest way into the Universe
is through a forest wilderness.

—John Muir

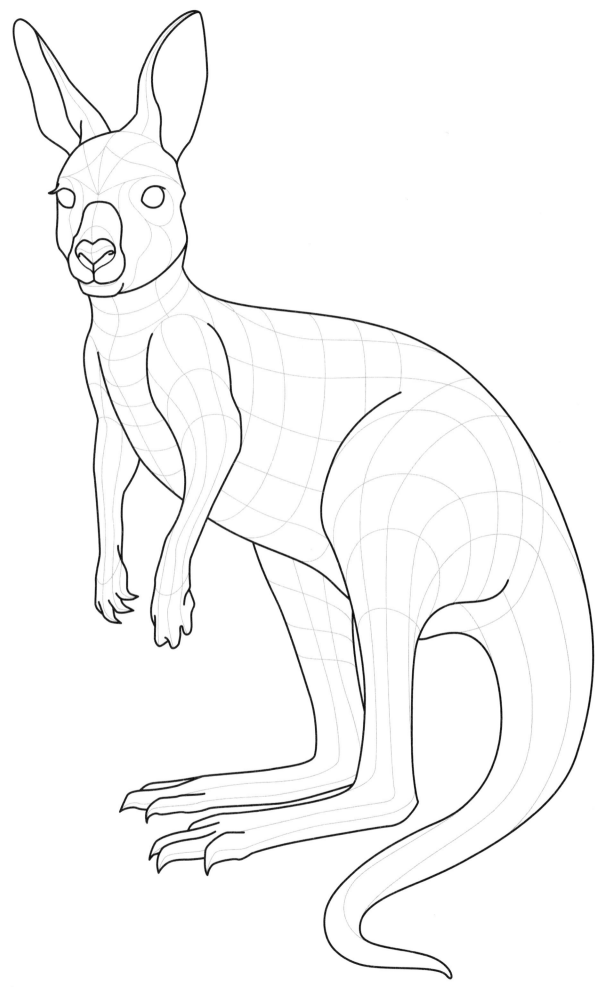

You belong somewhere you feel free.

—Tom Petty, *Wildflowers*

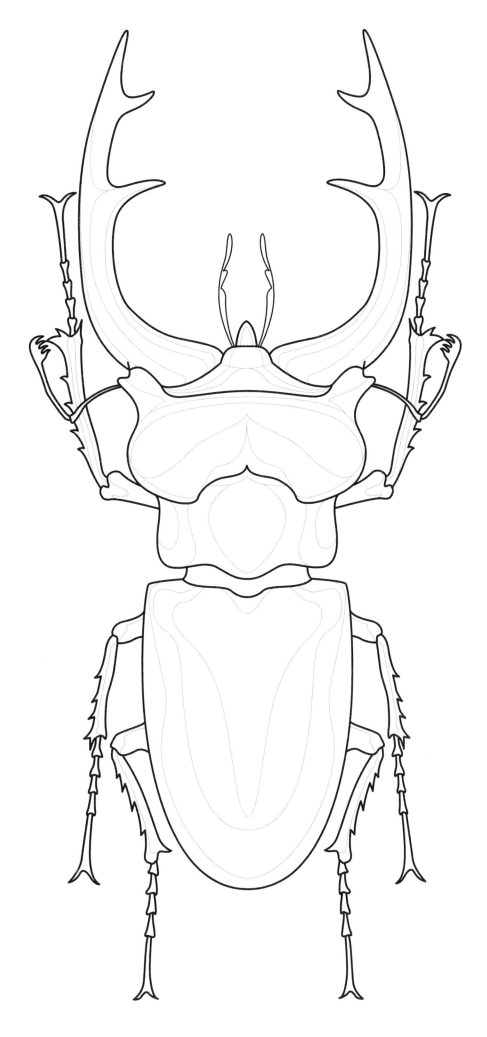

If one really loves nature, one can
find beauty everywhere.

—Vincent van Gogh

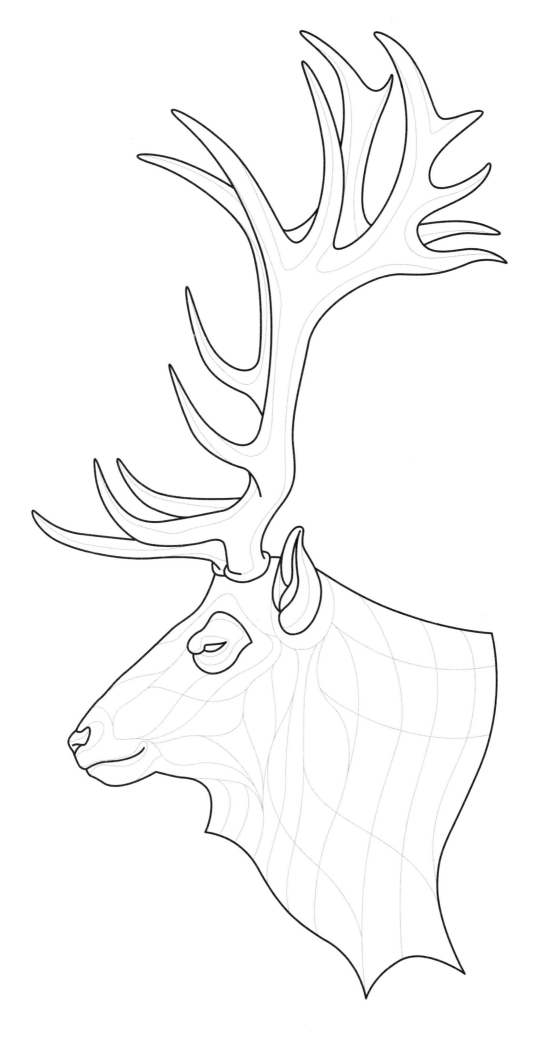

© Ben Kwok

The Poetry of earth is never dead.

—John Keats

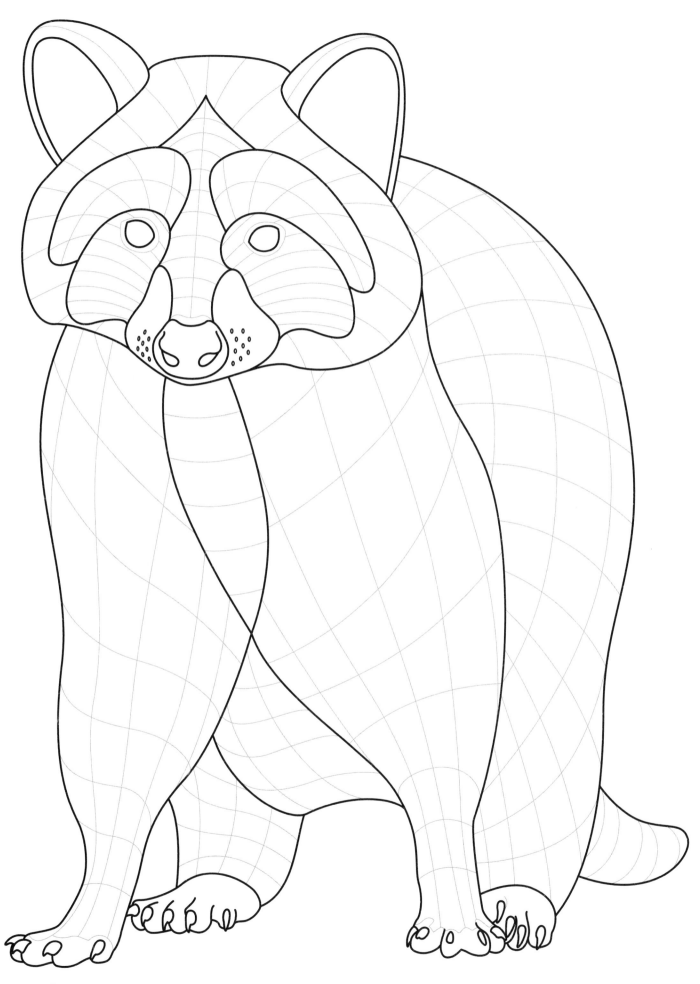

© Ben Kwok

Love the world and yourself in it...

—Audrey Niffenegger, *The Time Traveler's Wife*

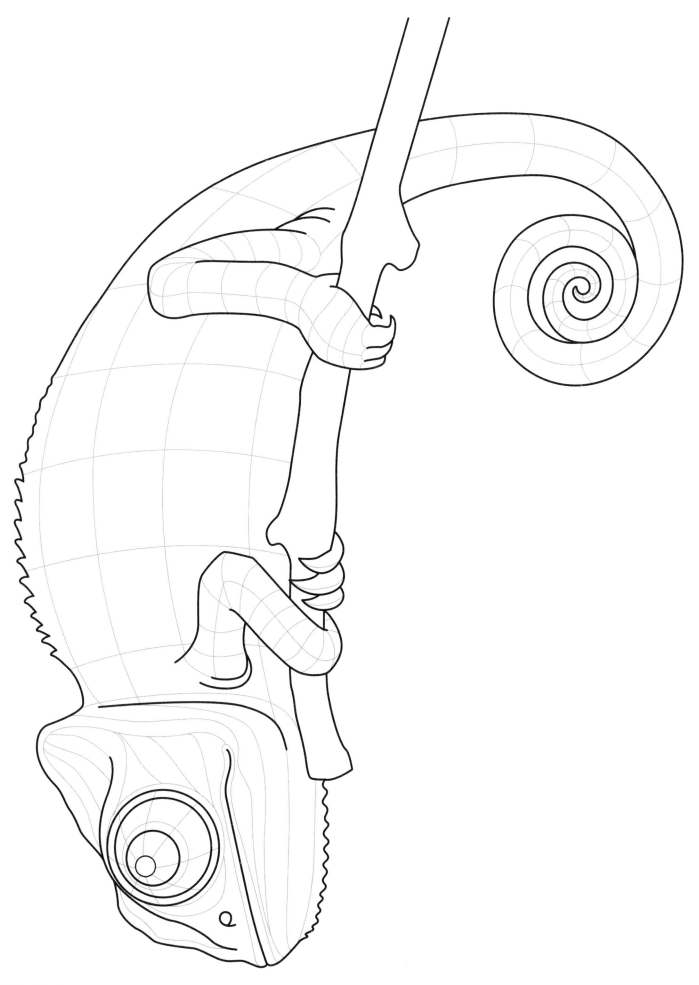

The earth is what we all have in common.

—Wendell Berry

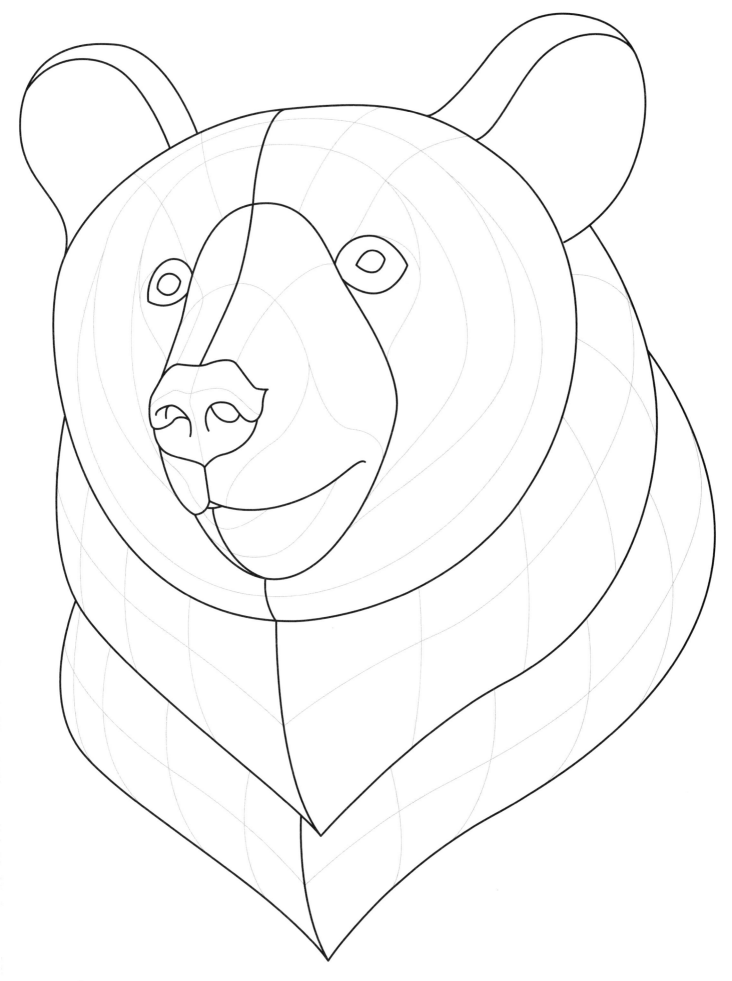

© Ben Kwok

Clearly, animals know more than we think,
and think a great deal more than we know.

—Irene M. Pepperberg

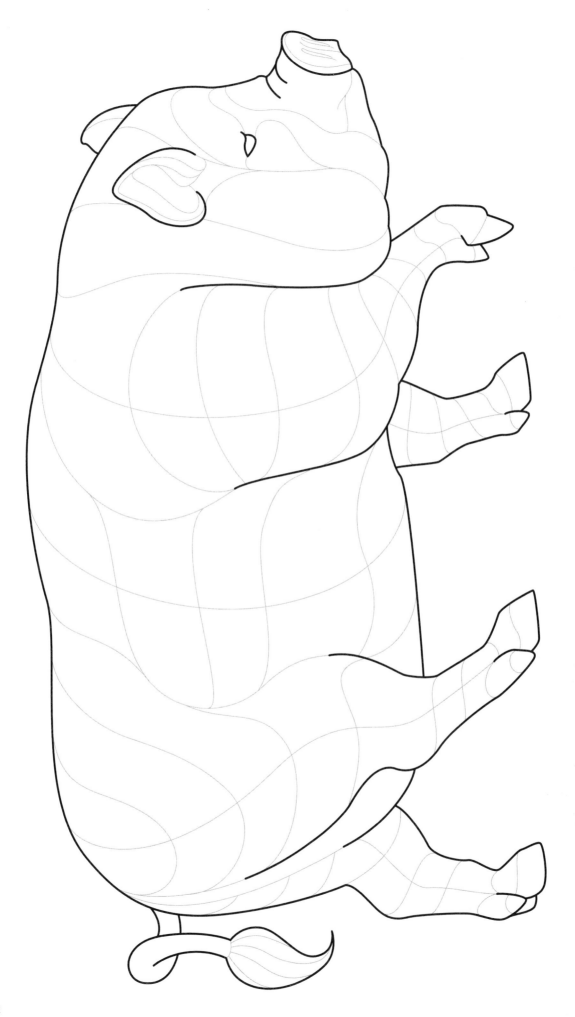

© Ben Kwok

Dream higher than the sky and
deeper than the ocean.

—Unknown

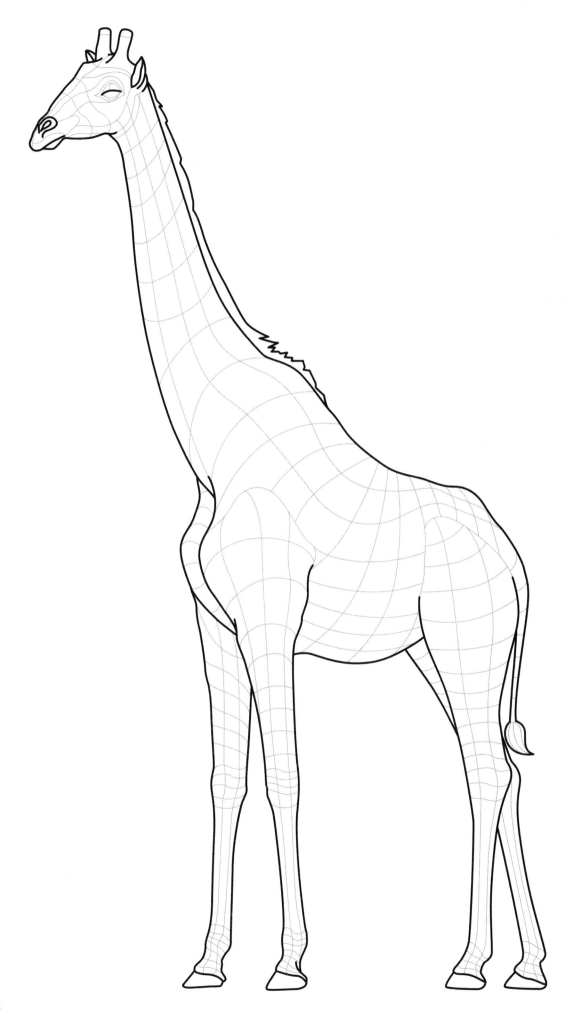

© Ben Kwok

In all things of nature there is
something of the marvelous.

—Aristotle

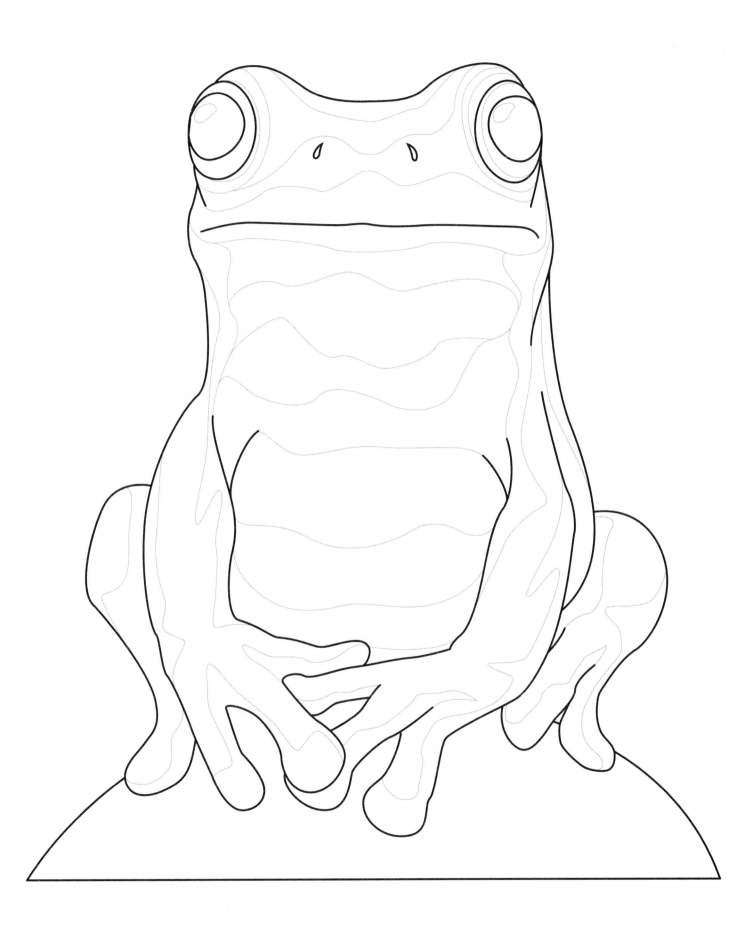

© Ben Kwok

The earth has its music for those who will listen.

—George Santayana

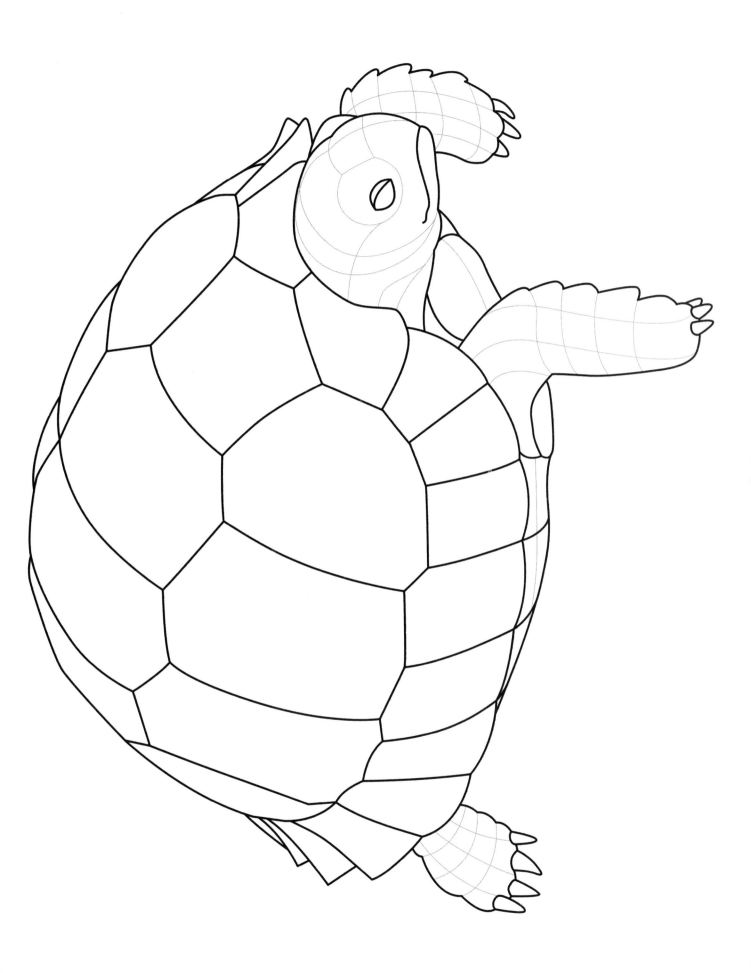

© Ben Kwok

Nature never hurries.
Atom by atom, little by little
she achieves her work.

—Ralph Waldo Emerson

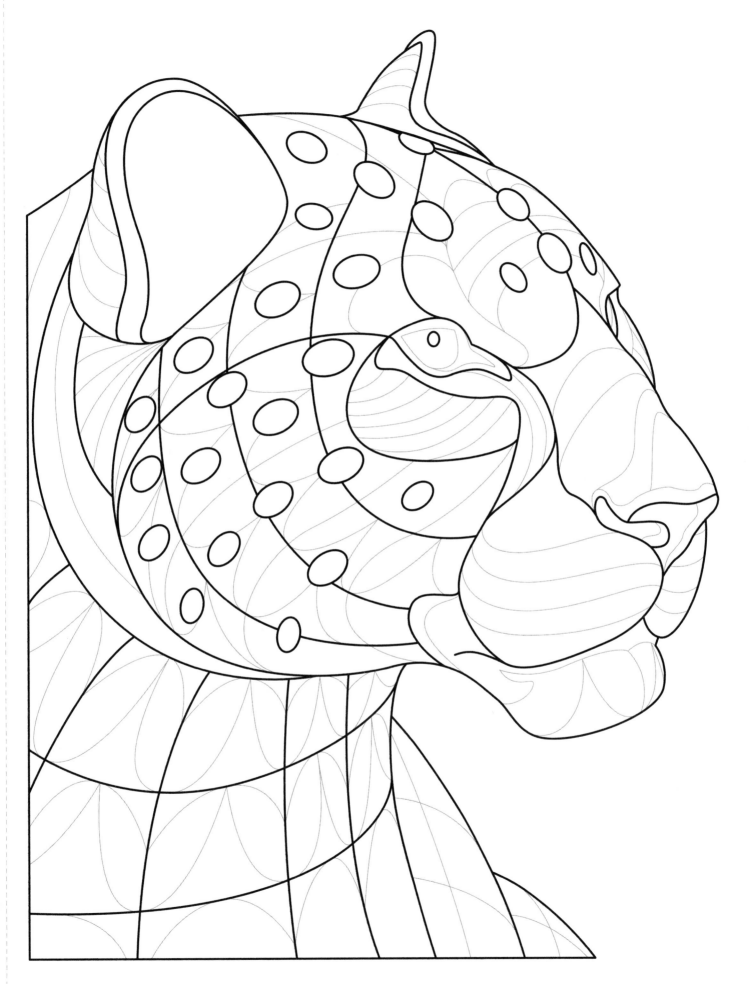

© Ben Kwok

A leopard does not change his spots,
or change his feeling that spots are
rather a credit.

—Ivy Compton-Burnett

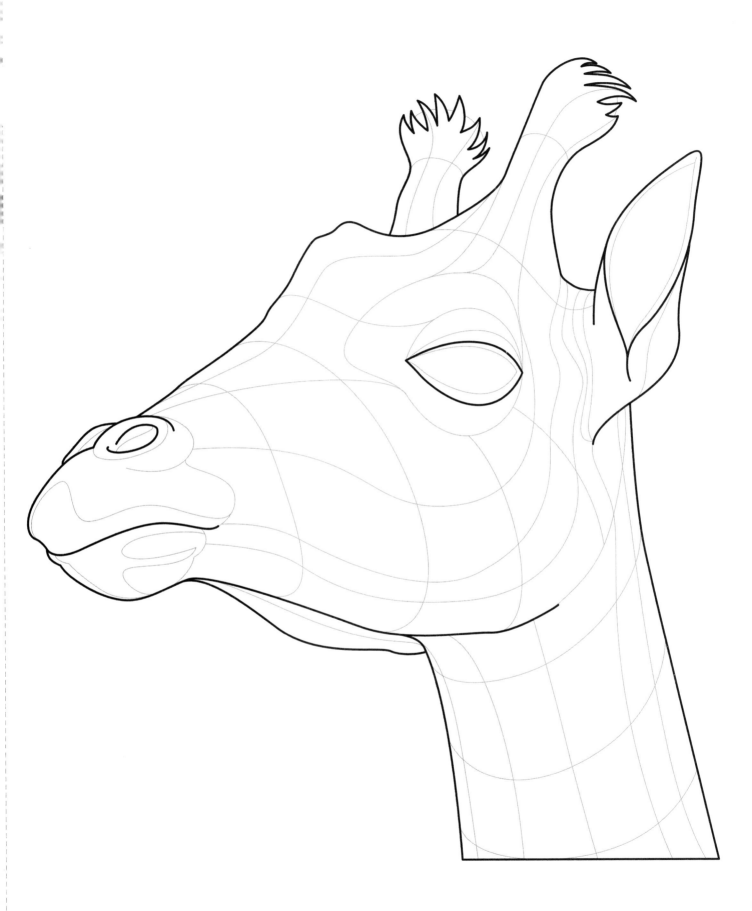

© Ben Kwok

Nature is not a place to visit. It is home.

—Gary Snyder

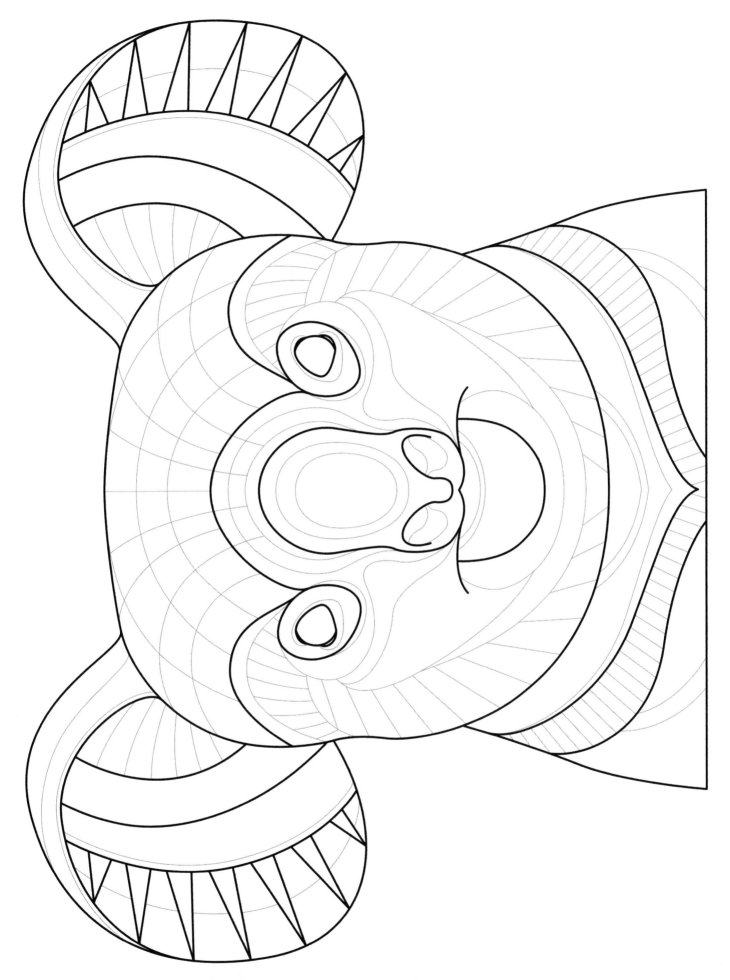

© Ben Kwok

All animals, except man,
know that the principle business
of life is to enjoy it.

—Samuel Butler

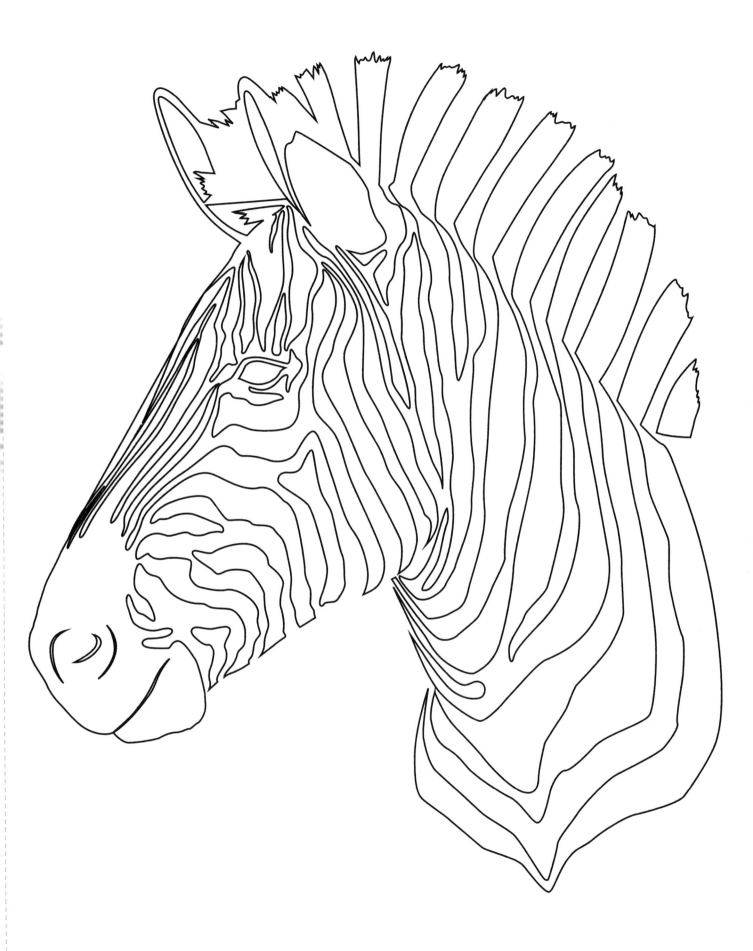

© Ben Kwok

The beauty of the natural world lies in the details.

—Natalie Angier

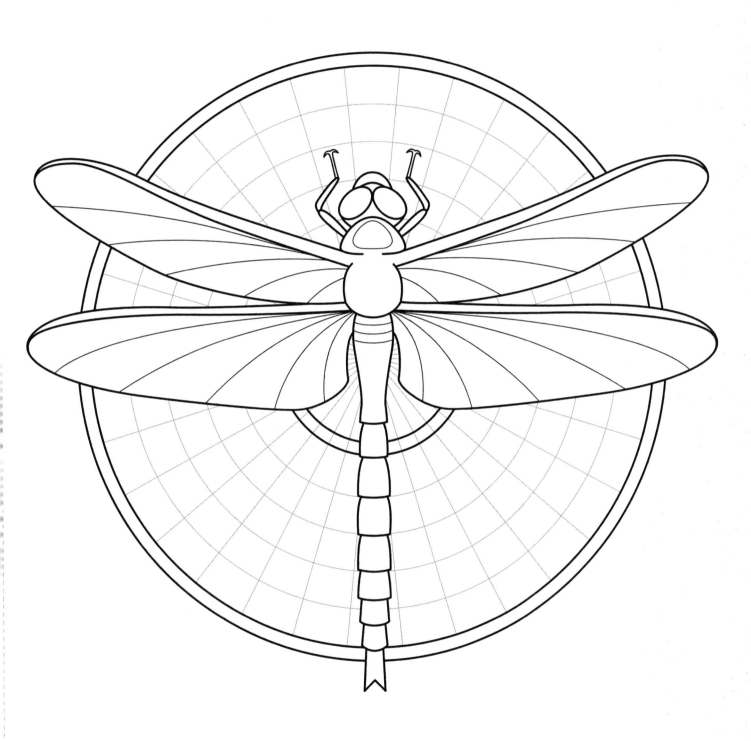

© Ben Kwok

I believe that there is a subtle
magnetism in Nature, which,
if we unconsciously yield to it,
will direct us aright.

—Henry David Thoreau

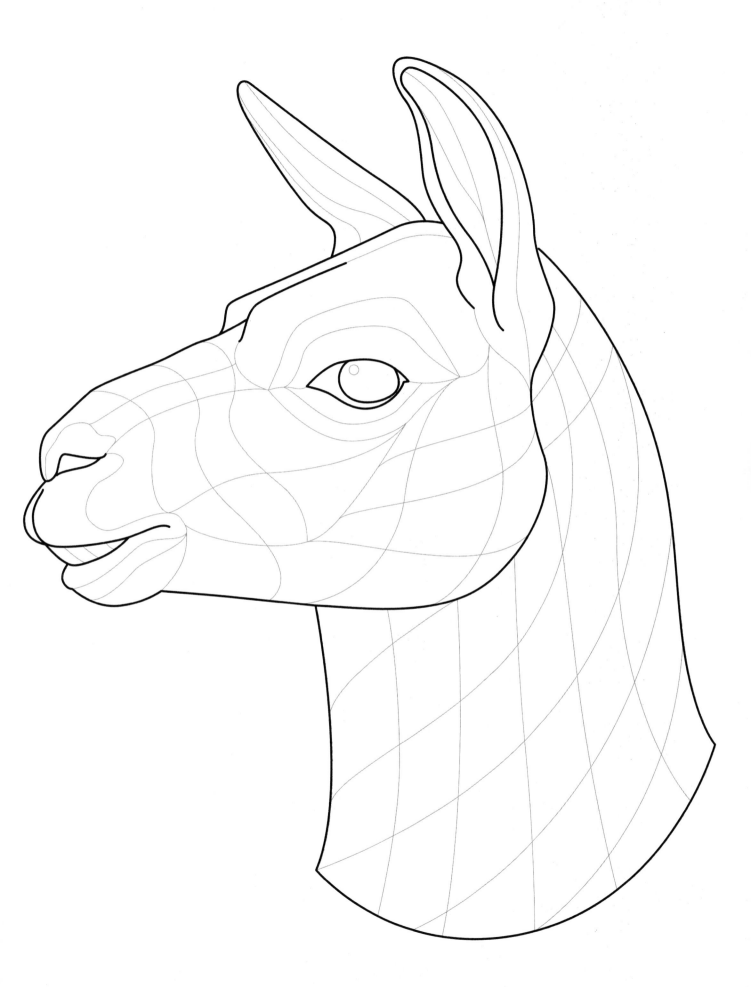

At some point in life, the world's
beauty becomes enough.

—Toni Morrison

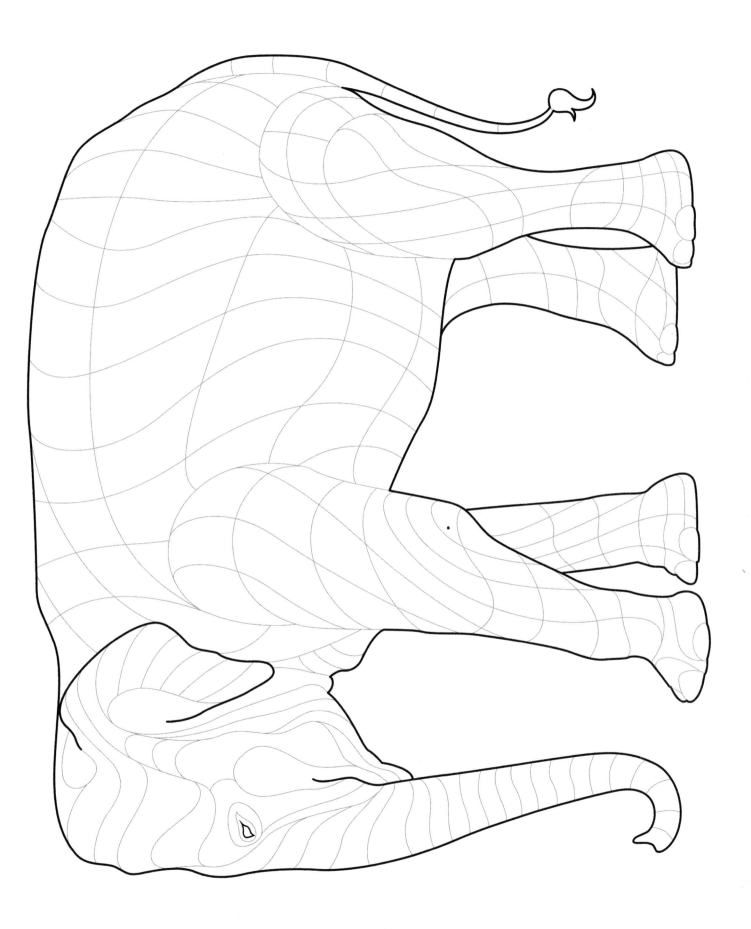

On earth there is no heaven,
but there are pieces of it.

—Jules Renard

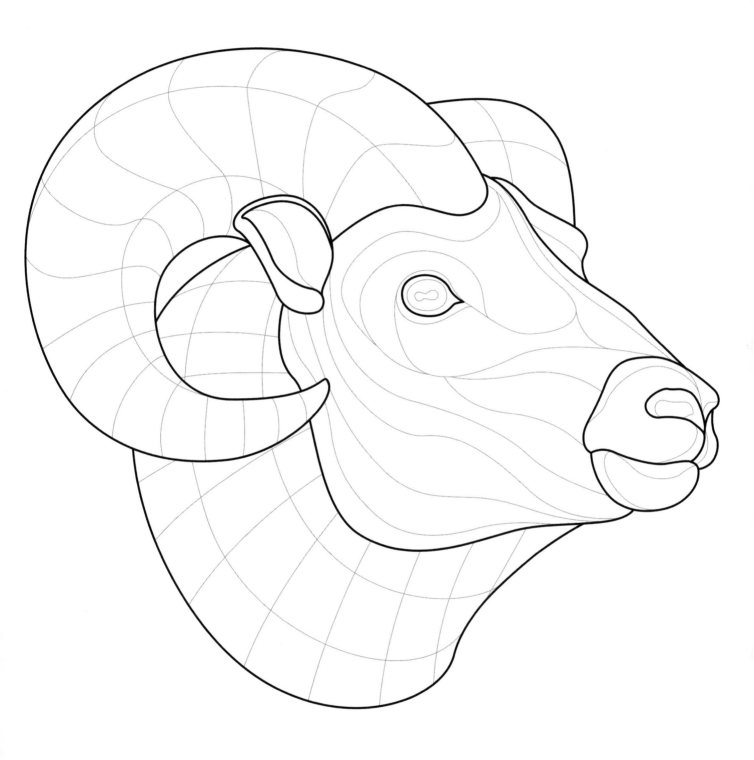

© Ben Kwok

The mountains are calling and I must go.

—John Muir

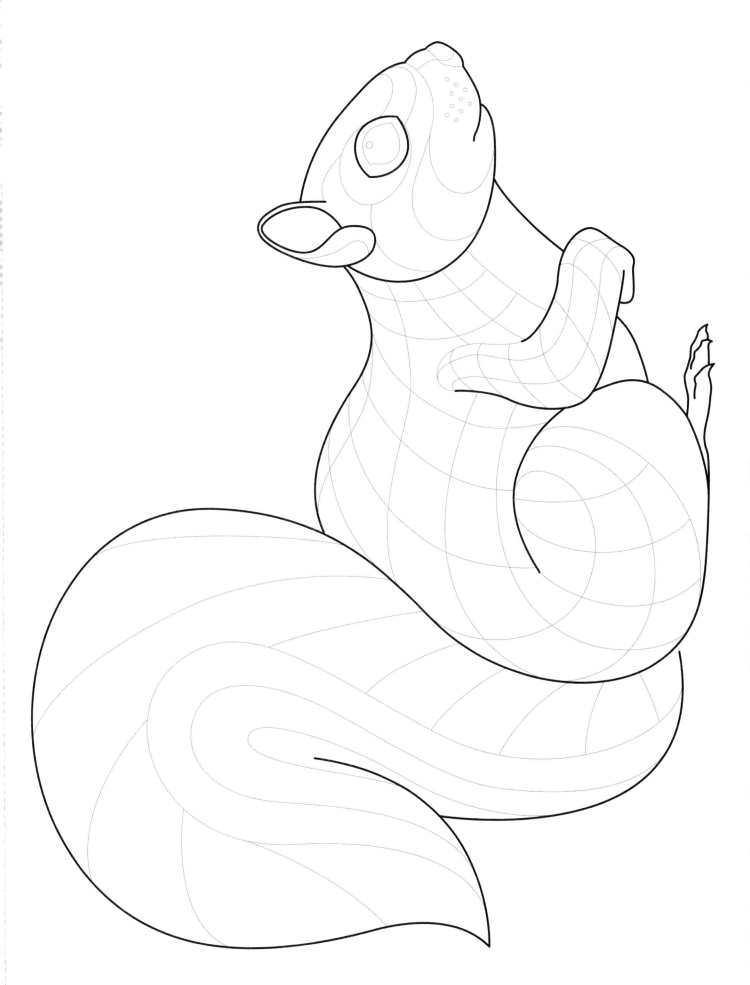

© Ben Kwok

I took a walk in the woods and came
out taller than the trees.

—Henry David Thoreau

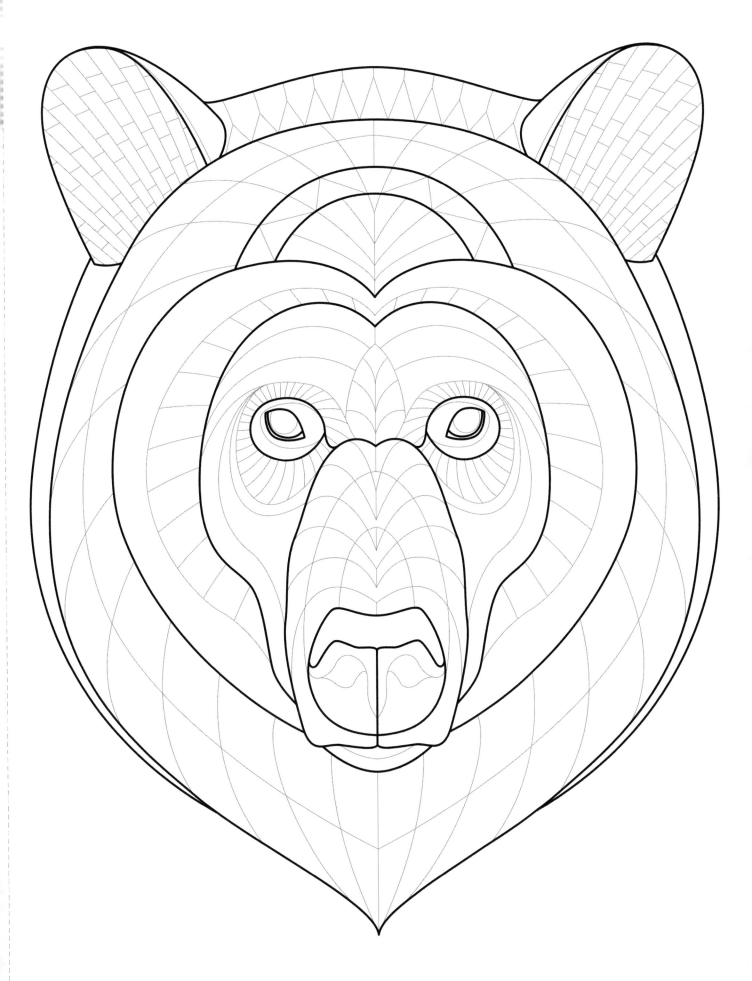

An animal's eyes have the power
to speak a great language.

—Martin Buber

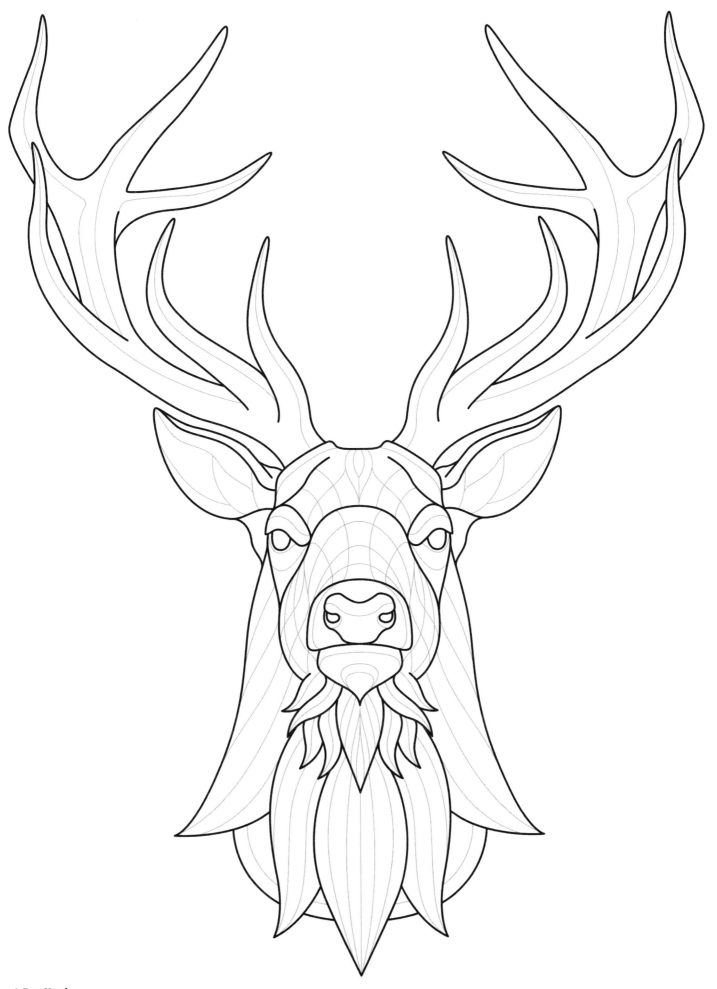

Keep your faith in all beautiful things.
In the sun when it is hidden. In the spring
when it is gone.

—Roy Rolfe Gilson

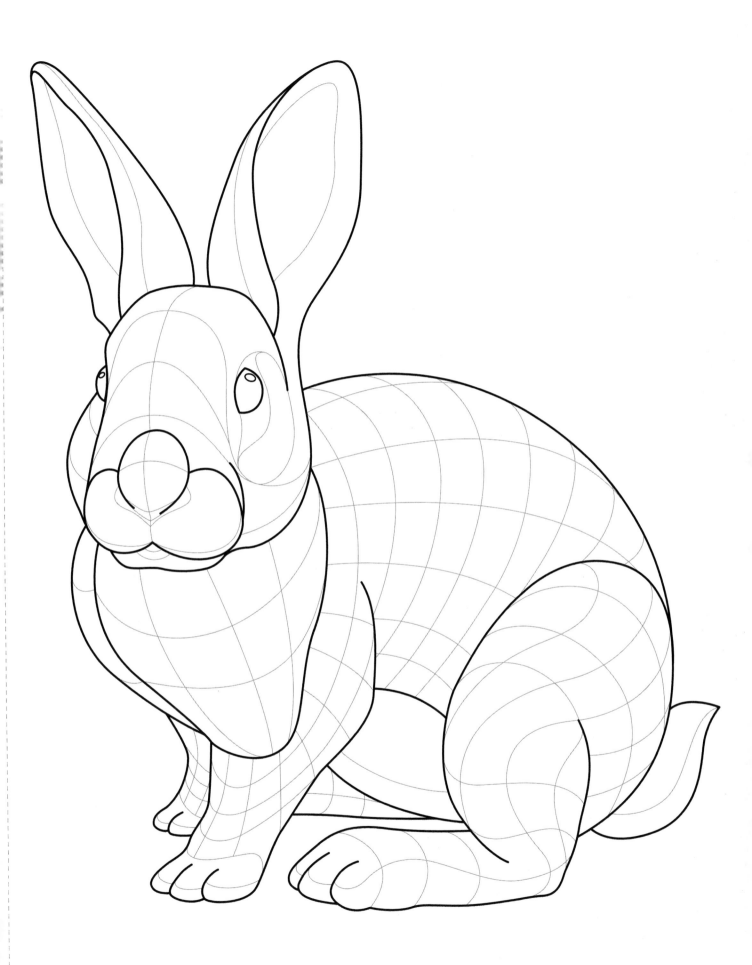

© Ben Kwok

I go to nature to be soothed and healed,
and to have my senses put in order.

—John Burroughs

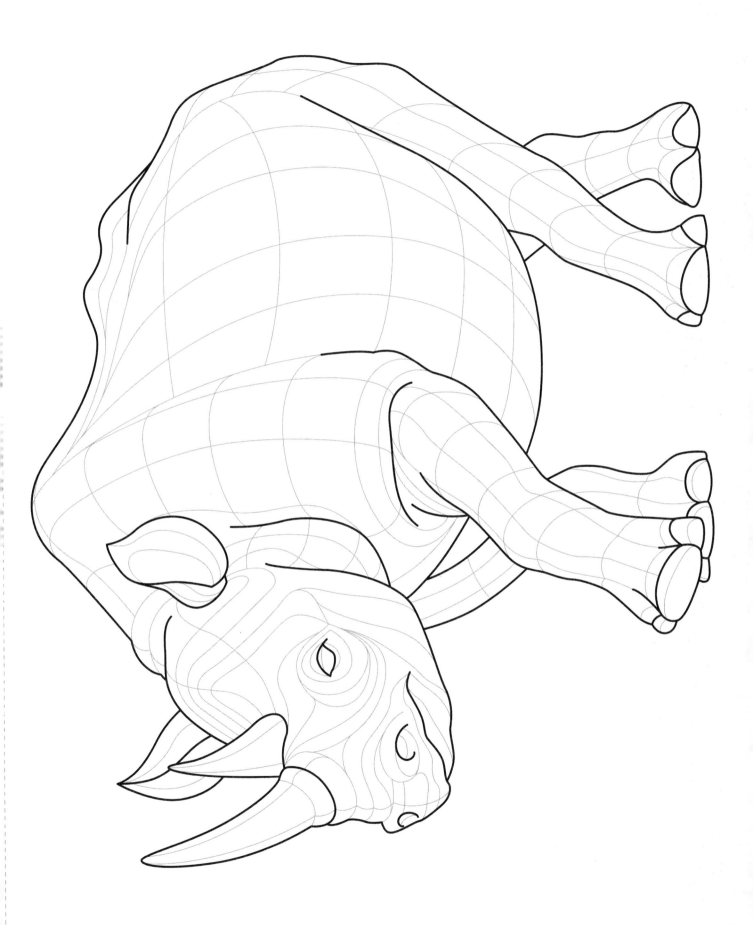

© Ben Kwok

Go out, go out I beg of you
And taste the beauty of the wild.
Behold the miracle of the earth
With all the wonder of a child.

—Edna Jaques

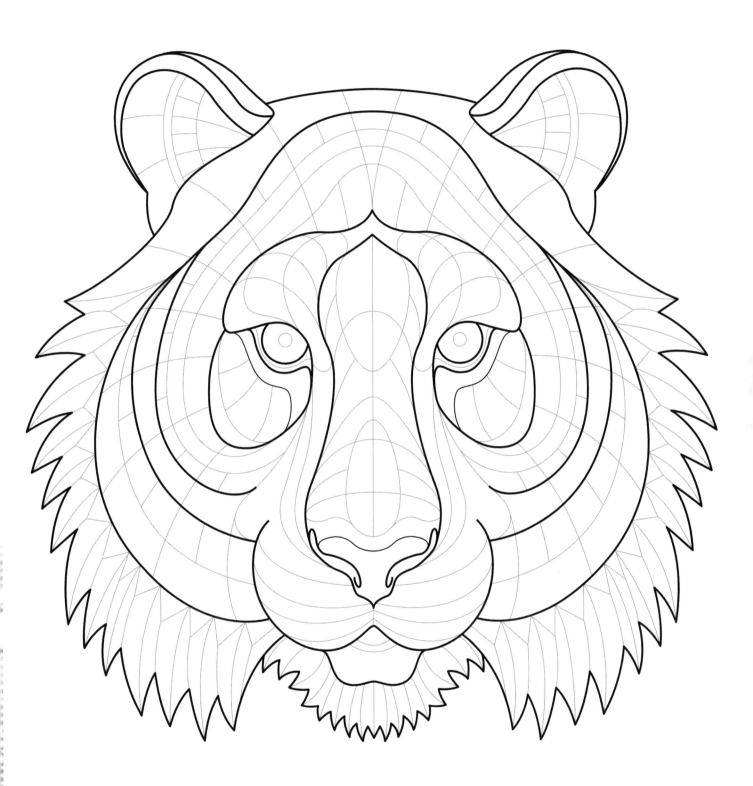

Like a true Nature's child,
We were born,
Born to be wild.

—Steppenwolf, *Born to Be Wild*

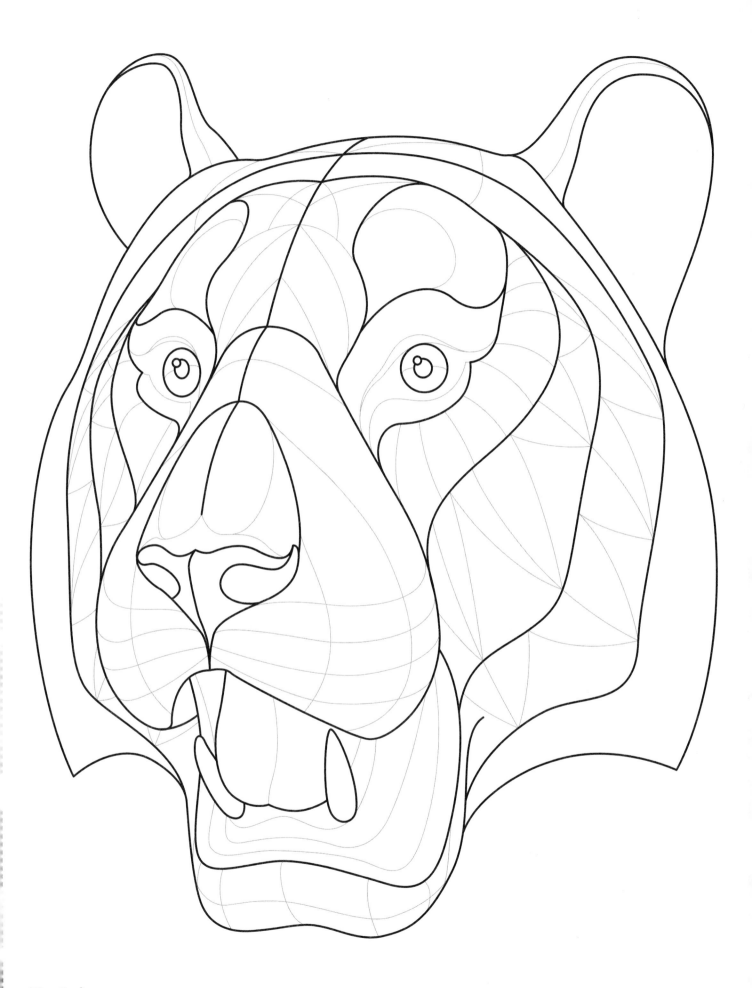

I got the eye of the tiger, a fighter, dancing through the fire
'Cause I am a champion and you're gonna hear me roar

—Katy Perry, *Roar*